I LOVE KAWAII
Copyright © 2011 Harper Design and Monsa Publications

HarperCollins books may be purchased for educational, business, or sales promotional use. For information please write: Special Markets Department, HarperCollins*Publishers*, 10 East 53rd Street, New York, NY 10022.

First published in 2011 by
Harper Design
An Imprint of HarperCollins*Publishers*
10 East 53rd Street
New York, NY 10022
Tel: (212) 207-7000
Fax: (212) 207-7654
harperdesign@harpercollins.com
www.harpercollins.com

Distributed throughout the world by
HarperCollins*Publishers*
10 East 53rd Street
New York, NY 10022
Fax: (212) 207-7654

Editor and project director:
Josep Mª Minguet

Selection and art director:
Charuca

Design by:
Rubén García Cabezas

Translation by:
Babyl Traducciones

ISBN: 978-0-06-208282-4

Library of Congress Control Number 2011932416

Printed in China
First Printing, 2011

I ♥ KAWAII

Selected by Charuca

HARPER
DESIGN

An Imprint of HarperCollins Publishers

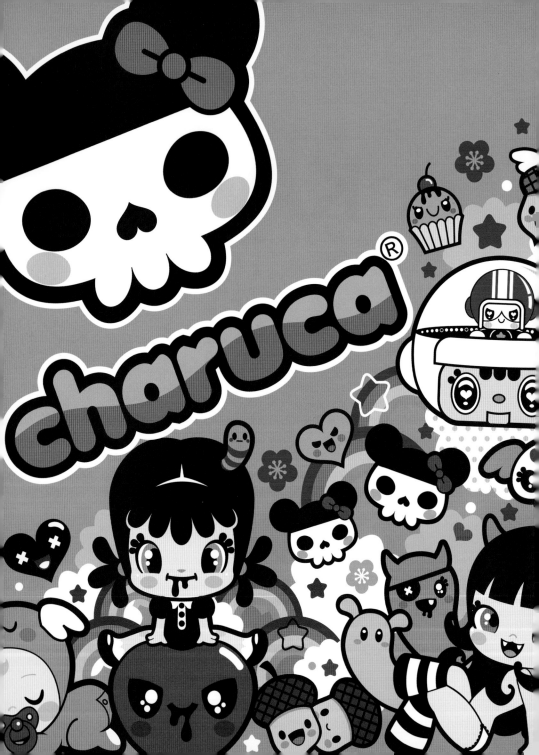

CONTENTS

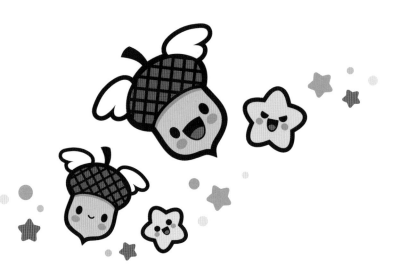
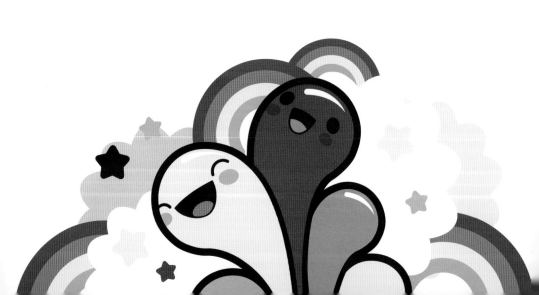

I LOVE KAWAII: INTRODUCTION

Kawaii is a Japanese word meaning "adorable, sweet, cute." It's common for the Japanese to exclaim, "Kawaiiiiii!!!" upon seeing something or someone that is exceptionally cute—a puppy, kitten, or baby, for example. Kawaii can also apply to anything that appears childish, both in terms of an object's graphic simplicity— geometrical and curved shapes and bright colors—and the humorous and/or positive message it conveys. Another feature of kawaii is that everything, be it object or animal, is humanized. The proportion between head and body is extremely distorted. A kawaii character usually has a head the same size as the rest of the body, sometimes even larger. Think of the world-famous Japanese icon Hello Kitty—the perfect global example of kawaii.

I had wanted to put together a book on kawaii art for some time. At the risk of sounding like a kawaii freak, I have to admit that I am a huge fan of the art. My love for it borders on the obsessive. Not only have I integrated some aspects of kawaii into my own artwork, but I have also sought out the best kawaii artists in the field to learn from them. Aside from this, being the compulsive collector of art books that I am, I could no longer stand the gap in my bookcase, which desperately needed filling with a collection on this type of art. After a great deal of research, I decided to create this book myself, presenting works of my own as well as those of my favorite artists. I felt an urgent need to share kawaii with the rest of the world if only to make life a little more pleasant and enjoyable. I want you to fall in love with kawaii just as I have.

The book you are holding in your hands is a whimsical compendium of kawaii-based creations from a handful of my favorite artists, many of whom are my friends. Each artist, of course, has his/her own unmistakable style. This book celebrates the art of kawaii—and the artists who are at the cusp of the form—for all its color, supercute graphics, and delightful sense of humor. I think these images are incredibly exciting; they carry me away to a dream world filled with bright colors and the sweet smell of candy.

I welcome you to my kawaii world, and hope you enjoy your trip.

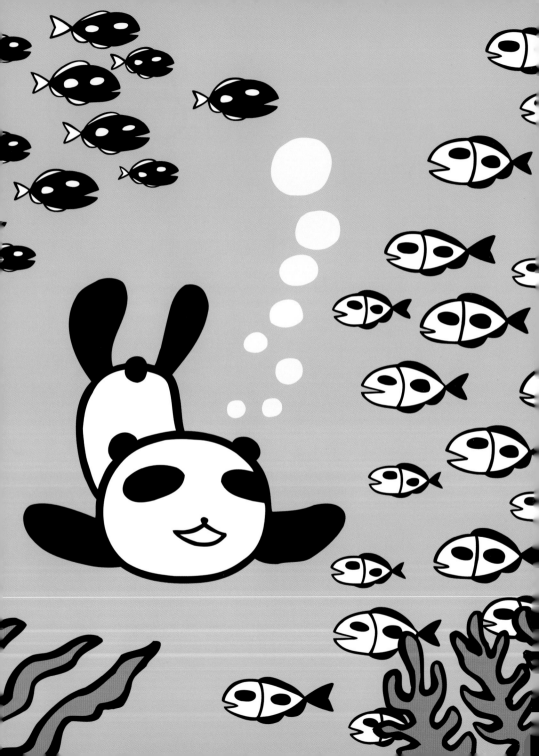

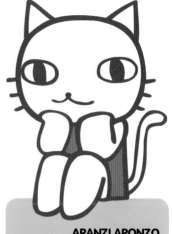

In 1991, Yoko Yomura and Kinuyo Saito created the brand Aranzi Aronzo. Their premise is quite simple: "To create and sell the sort of things we like." Yomura and Saito began by creating fabric dolls in their homes and selling them in shops. Aranzi Aronzo currently employs twenty staff members and makes all types of products; each product is treated and created with love. Aranzi Aronzo puts quality before quantity and any product bearing this name is vigorously inspected for quality control. Aranzi characters are unmistakable: They have a captivating style with some highly amusing graphics. Their shop in Daikanyama, Tokio, is well worth a visit.

ARANZI ARONZO
Osaka, Japan
www.aranziaronzo.com
tokyo@aranziaronzo.com

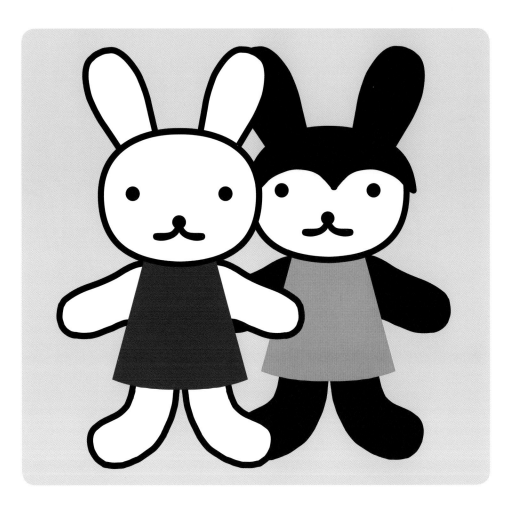

p10
WHITE RABBIT BROWN BUNNY

p11
T-shirt design

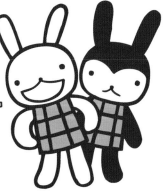

White Rabbit
Brown Bunny

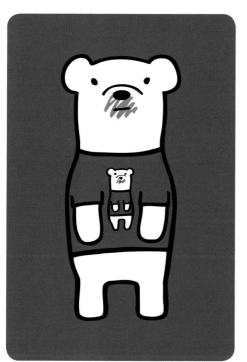

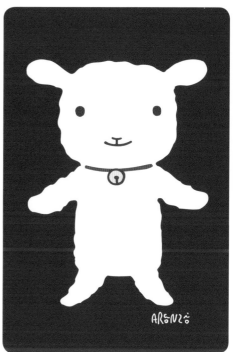

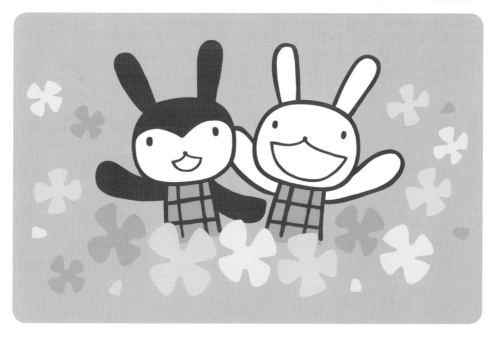

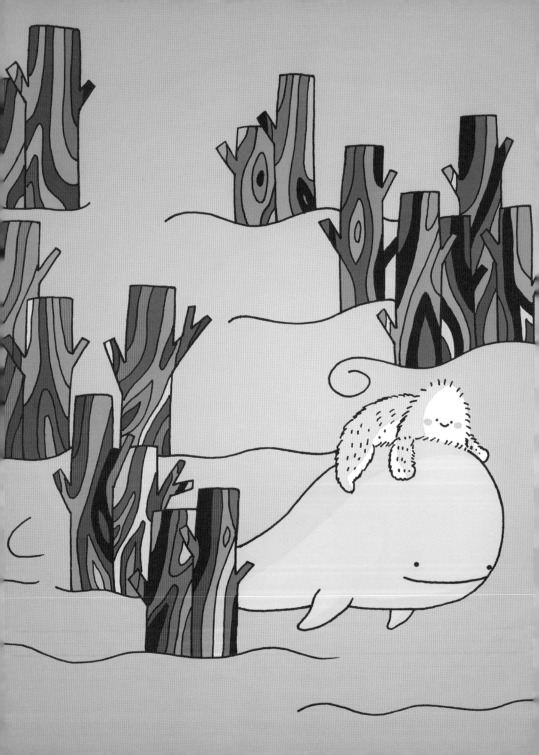

Bubi
AuYeung

MILKJAR.COM

Bubi was born and grew up in Hong Kong where she worked as a multimedia professional by day and a passionate illustrator by night. She has always enjoyed drawing, reading comics, and collecting dolls. In 2004, she became a freelance illustrator, creating a series of stories drawn with her own characters. "Treeson," her most famous character, was born on August 8, 2005. This character has a marshmallow-like body and a stem branching out of his heart. (But don't worry, he's not in pain.) Bubi is a highly respected artist on the kawaii scene. Her work is simply adorable—the embodiment of kawaii.

BUBI AU YEUNG
Hong Kong, China
www.milkjar.com
bubi@milkjar.com

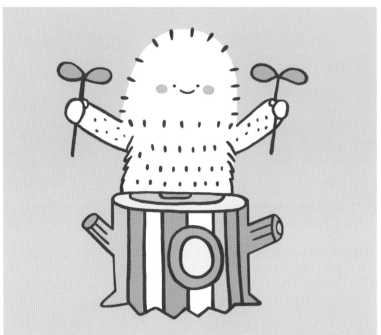

p14
Treeson illustrations

p15
Treeson illustrations

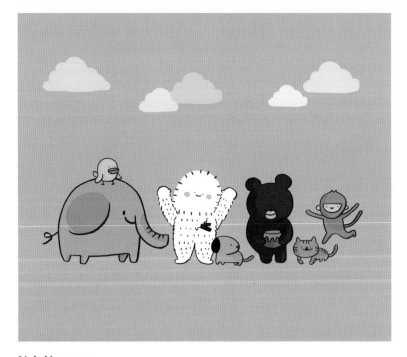

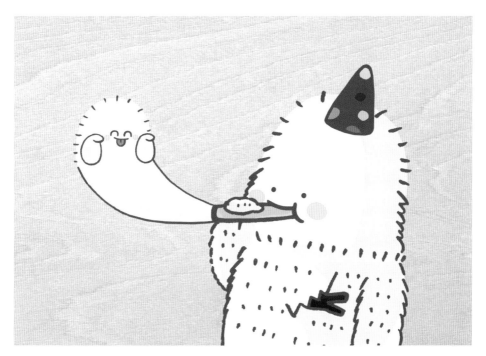

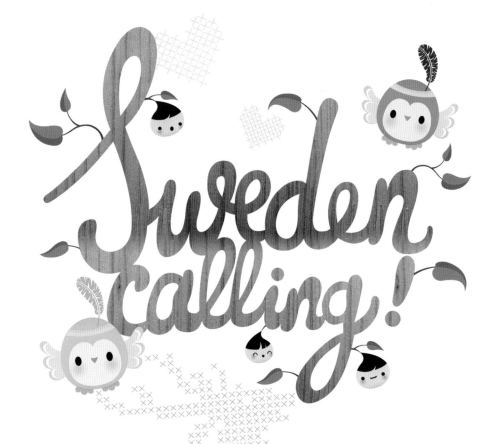

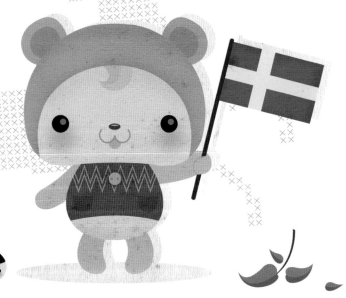

bukubuku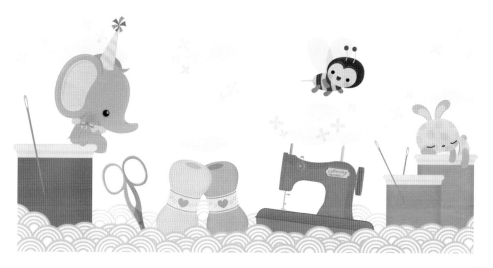

Having closely witnessed the artistic development of my friend Silvia Portella Torres, otherwise known as Bukubuku, I feel particularly fond of her work. I first met Silvia in Barcelona. Thanks to her, I discovered the city's most popular kawaii spots. Silvia has been working within the origins of kawaii illustration and has finally been given free reign. The result is a collection of some extremely sweet characters, who live in a unique setting—a visual mash-up, perhaps, of her birthplace Barcelona and the city of Berlin, where she has now lived for some years. Her creations can be seen in numerous German publications as well as in the form of some very tasty products on sale in her shops in Etsy or Poketo.

BUKUBUKU
Berlin, Germany
www.hellobukubuku.wordpress.com
bukubuku@gmx.de

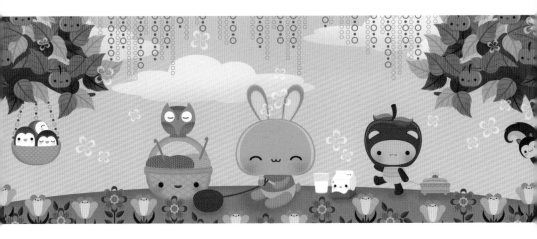

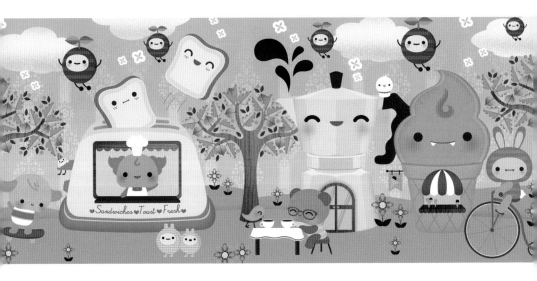

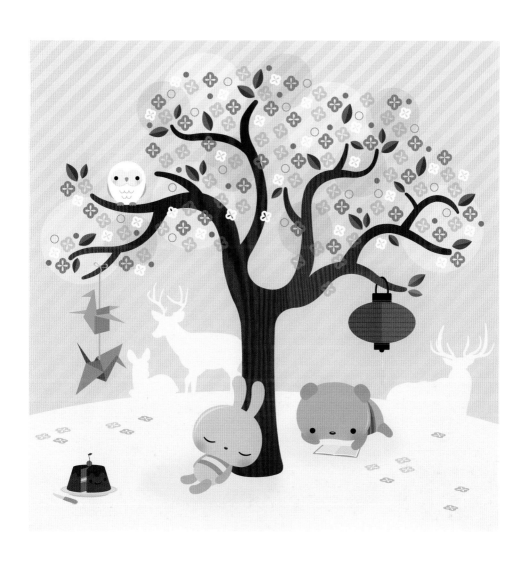

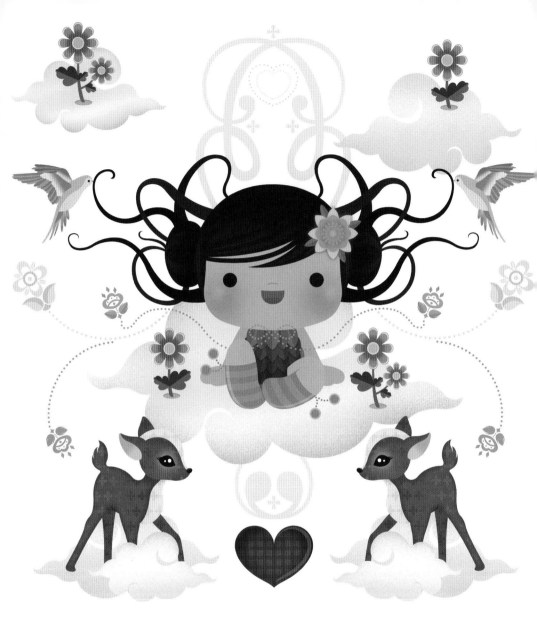

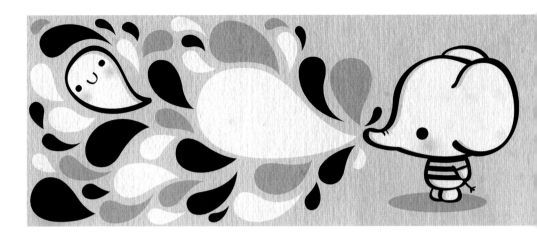

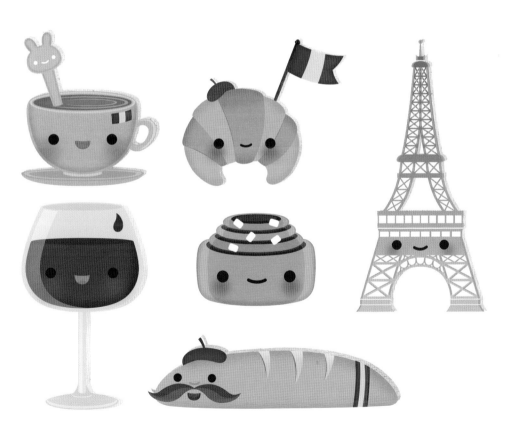

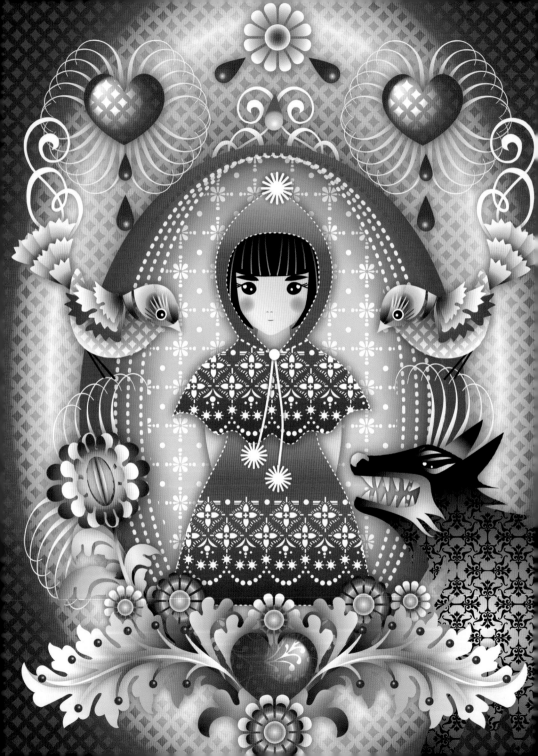

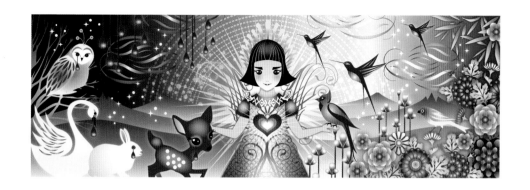

CATALINA ESTRADA

Catalina Estrada has a spirit full of light. This is what I felt the first time I visited one of her exhibitions at the Iguapop Gallery. It was there the arrow struck and with it my unconditional love for this Columbian artist, the indefatigable worker now settled in Barcelona. Catalina and her art are one. Light, beauty, a message of hope, and another of criticism. Small birds and deer live together with bloodthirsty wolves. They are part of the same life. Catalina combines her artistic projects with commercial ones as long as they have an influence on her accessories and lifestyle products. She also works on photography and illustration projects with her husband Pancho Tolchinsky.

CATALINA ESTRADA
Barcelona, Spain
www.catalinaestrada.com
catiestrada@gmail.com

p24
LITTLE RED RIDING HOOD
Vector illustration

p25
MOTHERLAND
Vector illustration

p26
BIRD
Published in *Computer Arts* magazine
Vector illustration

p27
UNICEF: LOVE IS ALL
For UNICEF
Vector illustration

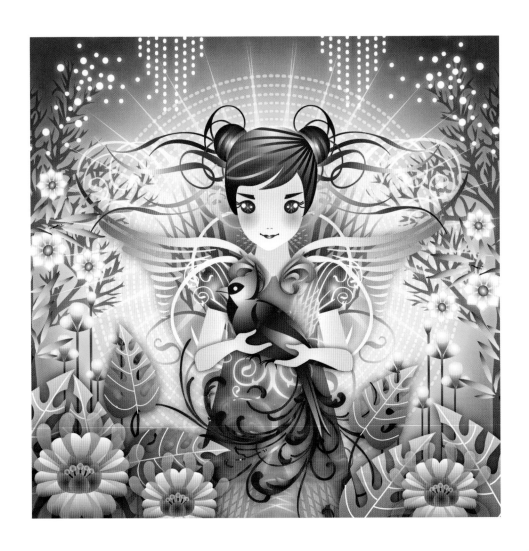

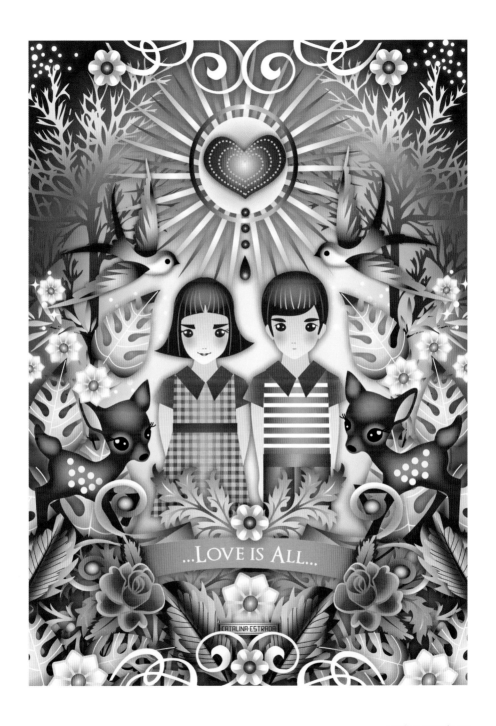

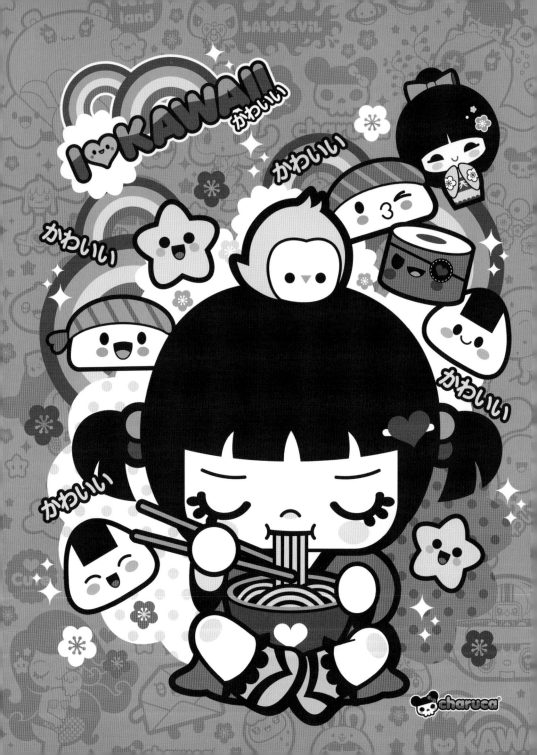

I am absolutely delighted to be able to share some of my work with you. In my gallery you can see Megamoder, my first collection of characters, which can also be seen on the Web site Mondotrendy.com. There were many more characters to come after Megamoder. I love each and every one of the characters I've created; they are my children! I also have a great deal of love for my BBZ toy collection, something I created jointly with Kachingbrands in 2007. I believe there's nothing more exciting for a character designer than to see their creature in the palm of their hand. The very first time I saw the BBZ prototypes I was almost in tears!

CHARUCA
Barcelona, Spain
www.charuca.net
charuca@charuca.net

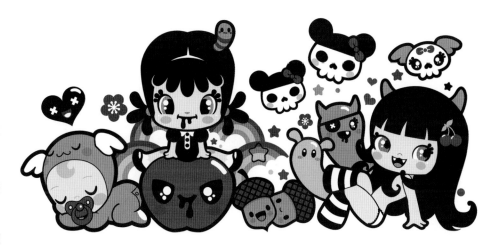

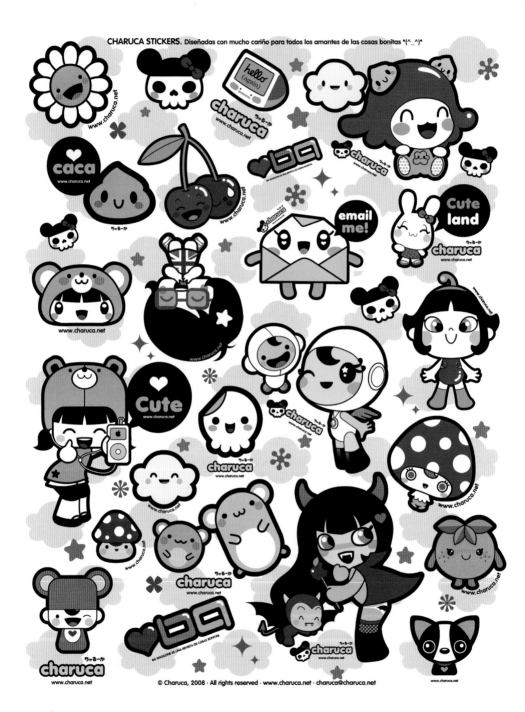

CHARUCA STICKERS. Diseñadas con mucho cariño para todos los amantes de las cosas bonitas *(^_^)*

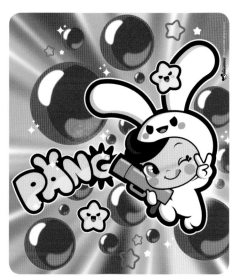

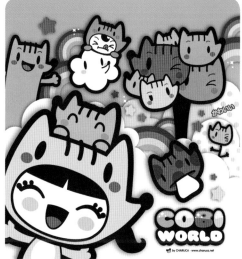

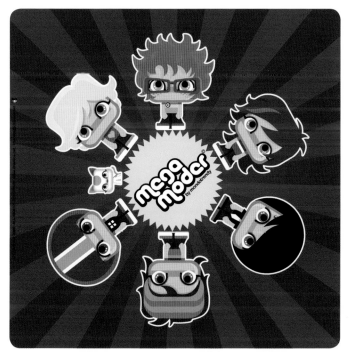

p30
CHARUCA STICKER SHEET
For *BG* magazine, n.29. Ecuador

p31
CHARUCA PANG
For the book *Designers' Games RMX*,
UBER BOOKS, Germany

COBI WORLD
Cobi's homage exhibiton by Duduá
in Barcelona

LOS MEGAMODER
First Internet characters by Charuca

Clém entine

For years I have been enchanted by the work of French artist Clémentine Derodit—smiling cherries and a milk bottle, which doubles as a baby panda. Clémentine has worked as a freelance designer since 2002 along with Mathieu Quiblier in the Bupla pool. The majority of her work consists of illustrations for children's magazines. She is also about to publish her first illustrated book titled *Et toque!*, which will be published by Marchand de feuilles Edition.

CLÉMENTINE
Lyon, France
www.bupla.com
clementine.derodit@free.fr

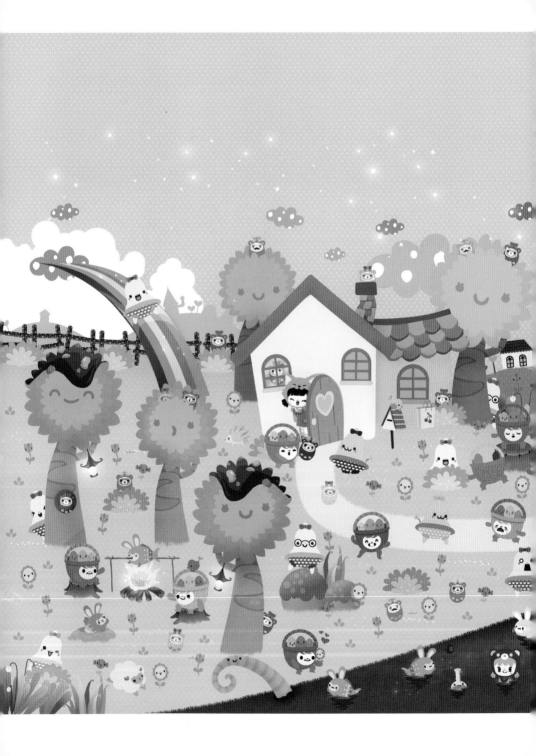

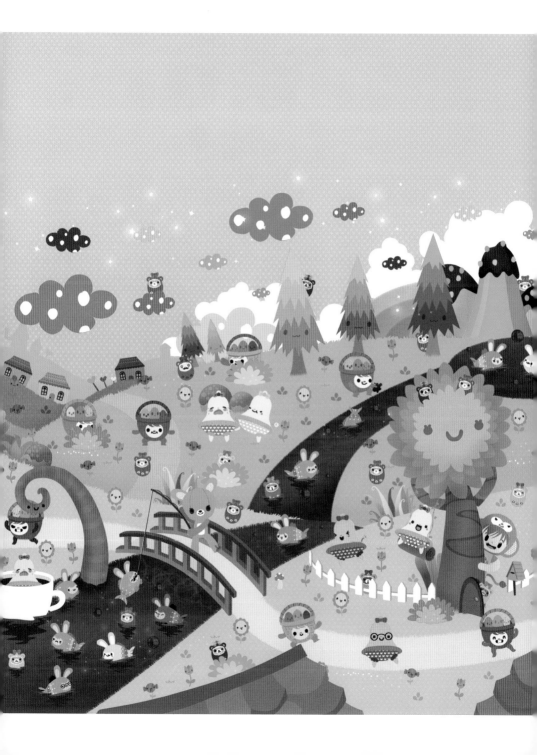

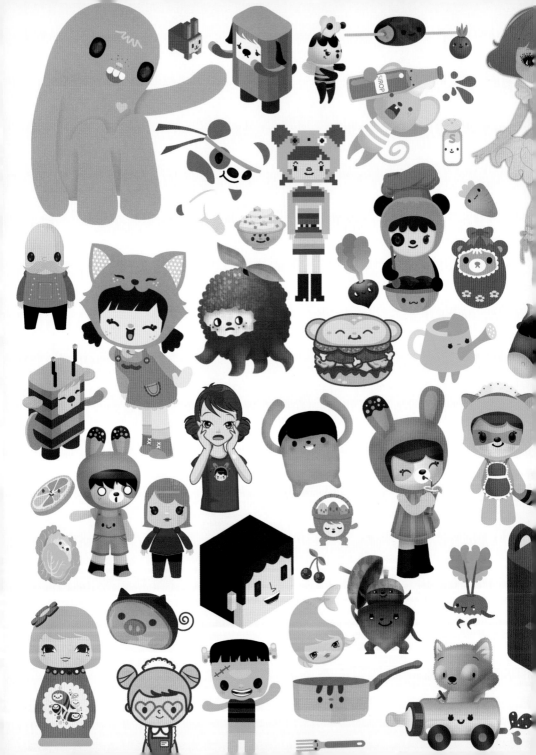

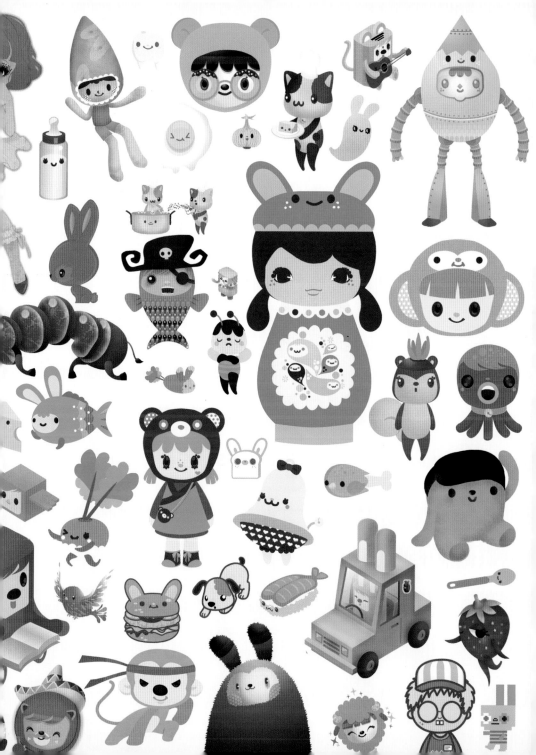

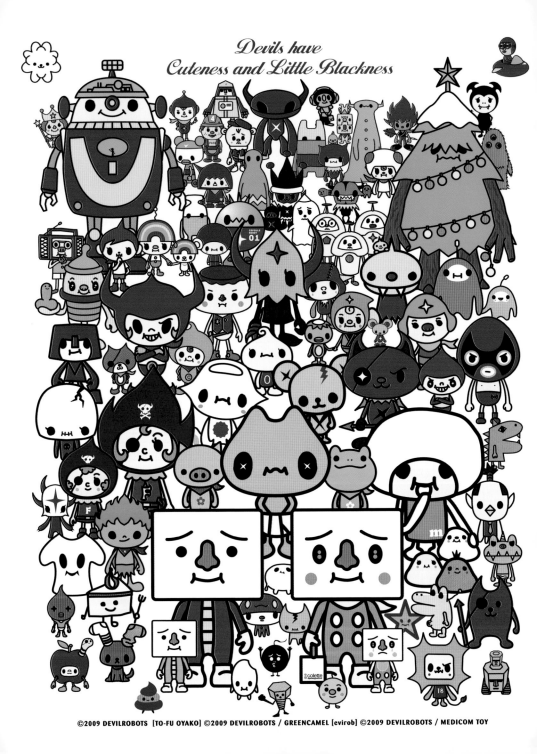

Devils have
Cuteness and Little Blackness

devil robots

Devilrobots is a studio in Tokyo, Japan. From a place crammed full of dolls and all types of pop items, Shinishiro Kitaii, the studio's art director, is effectively a dispenser of kawaii characters. The studio specializes in the creation of graphics, characters, illustrations, animation, Web sites, and music. I have to confess I feel a certain predilection for Shinishiro and Devilrobots. Their characters require no introduction. You may already be familiar with their most famous character, To-Fu Oyako, a product featured in countless specialized design shops.

DEVILROBOTS
Tokyo, Japan
www.devilrobots.com
kitai@devilrobots.com

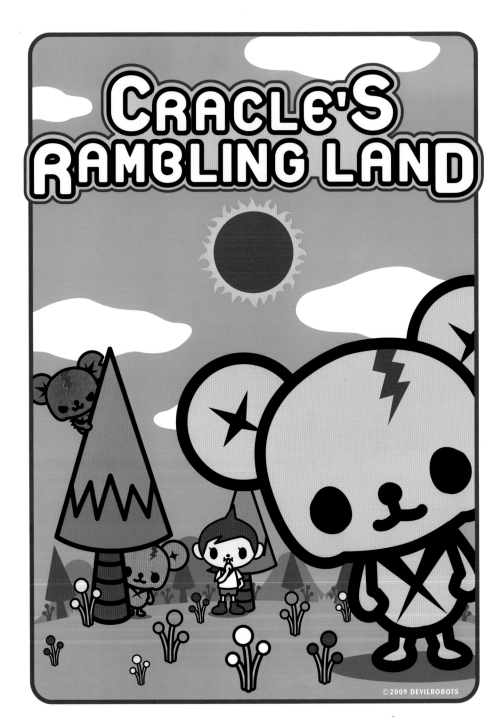

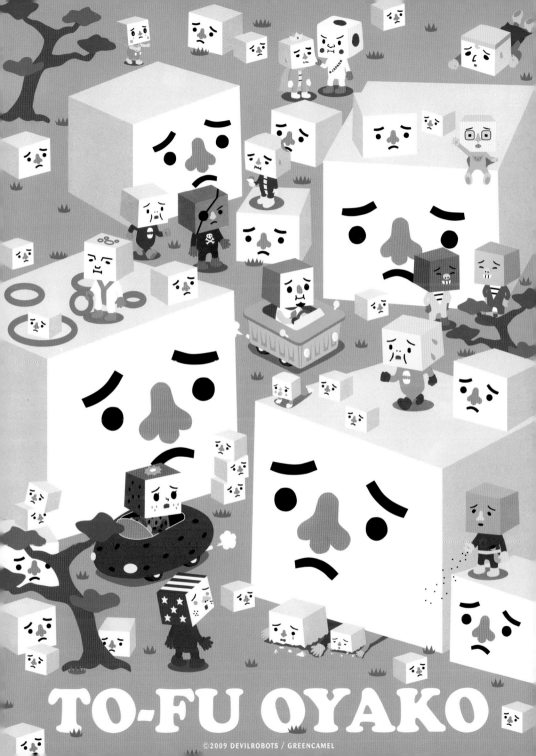

TO-FU OYAKO

ALICE IN WONDERLAND

Designed by DEVILROBOTS

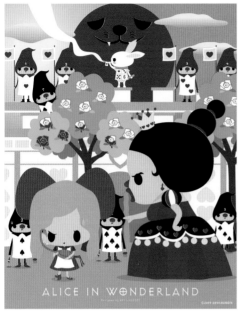

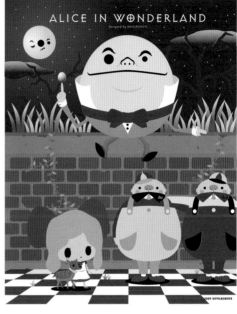

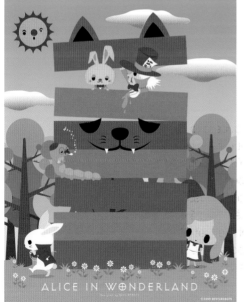

p42
ALICE IN WONDERLAND

p43
ALICE IN WONDERLAND

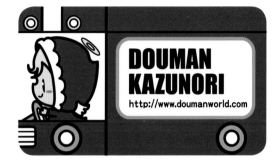

Douman's illustrations are 100 percent kawaii, in the broadest sense of the term. Douman also has the indisputable Japanese touch, which stems from the most classic kawaii. Small, smiling animals, very childish illustrations, small rounded shape—nobody can resist saying,"Ahhhhh!" Douman says she is good at doing humorous illustrations and that she would like to illustrate amusing stories of interest to people. She is currently working as an illustrator for magazine and book publishers, Web sites, and advertising firms.

DOUMAN
Japan
www.doumanworld.com
dmankazu@ybb.ne.jp

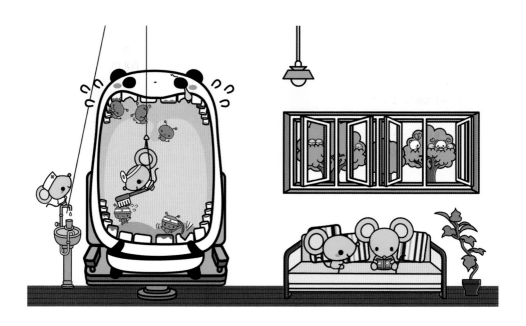

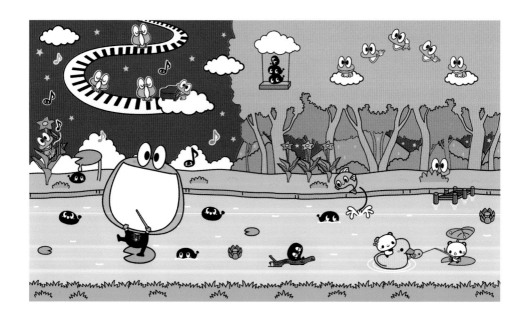

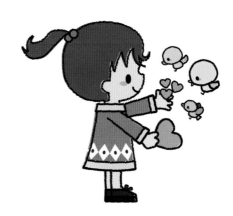

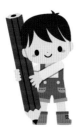
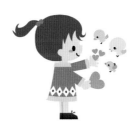
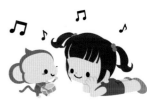

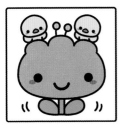 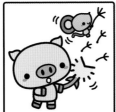

 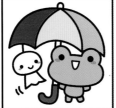 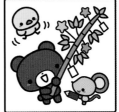 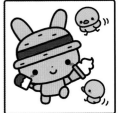

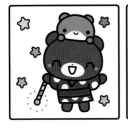

p48
ANIMALS 1

p49
ANIMALS 2

 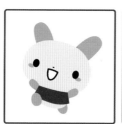

 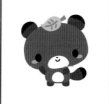 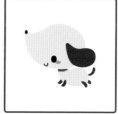

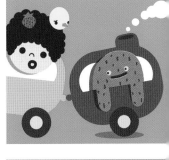

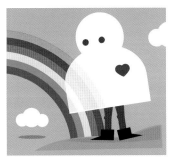

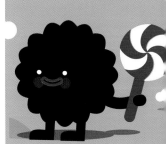

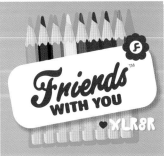

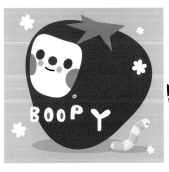

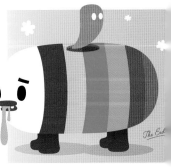

p50
Illustration for *Xlr8r* magazine

p51
WISH COME TRUE
Toy collection
Produced by Strange CO

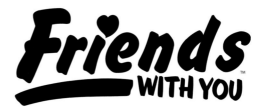

Friends With You is an artistic collaborative based in Miami, Florida, and founded by artists Samuel Borkson and Arturo Sandoval. Since 2002, FWY have been endorsing their message of magic, luck, and friendship, these being the core concepts the artists communicate through their collections of art toys and installations, and advertising campaigns. Their style is characterized by a minimalist approach to design and an explosion of primary colors, nearly always balanced with white. Best of all? FWY want to be your friends!

FRIENDSWITHYOU
Miami, USA
www.friendswithyou.com
info@friendswithyou.com

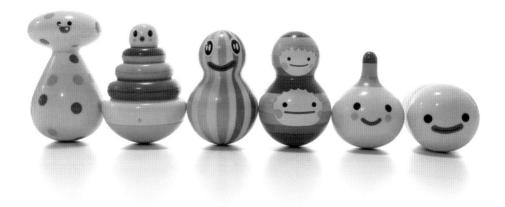

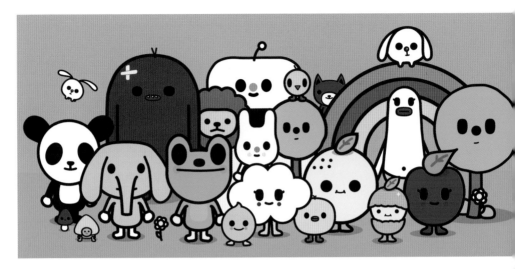

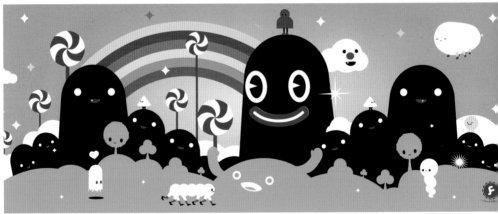

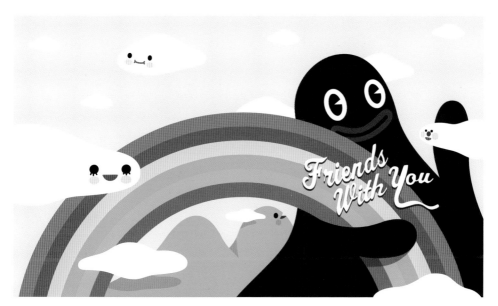

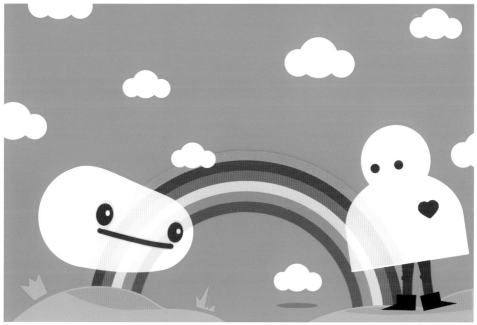

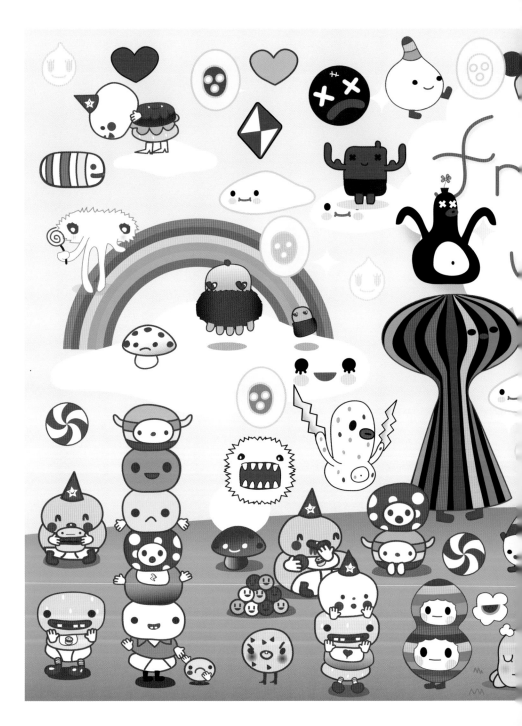

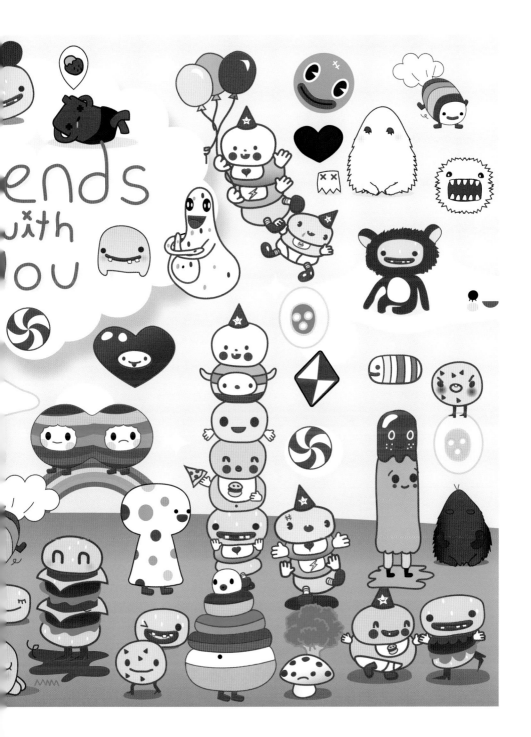

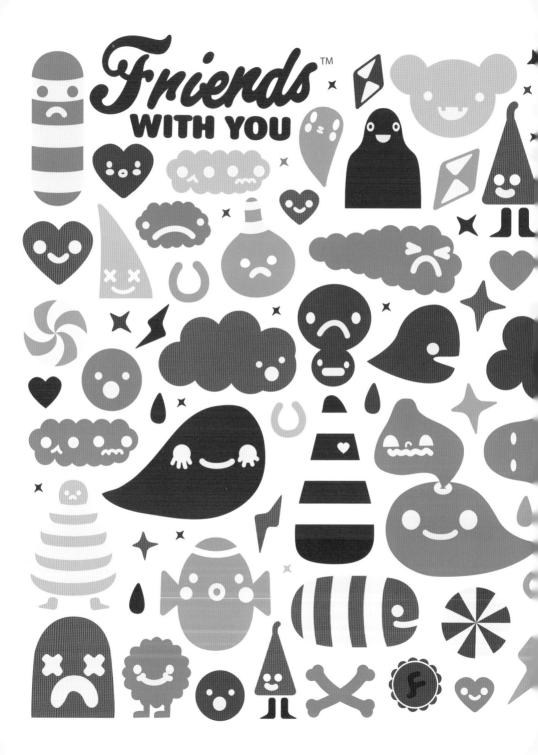

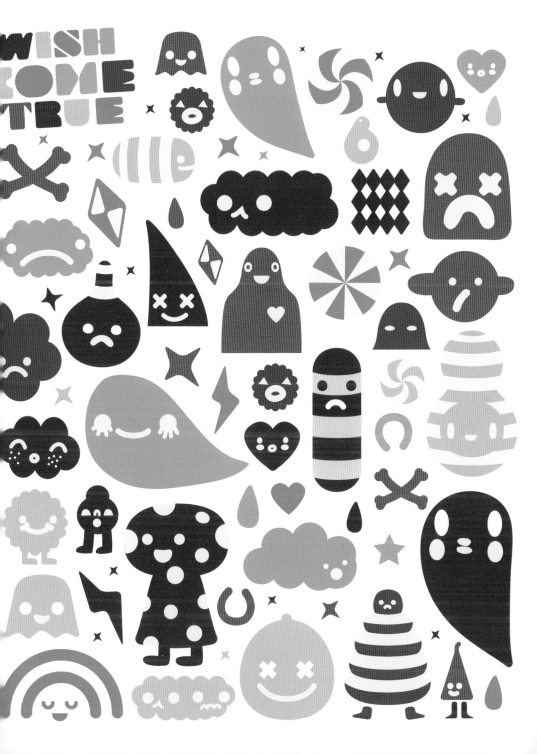

WISH
COME
TRUE

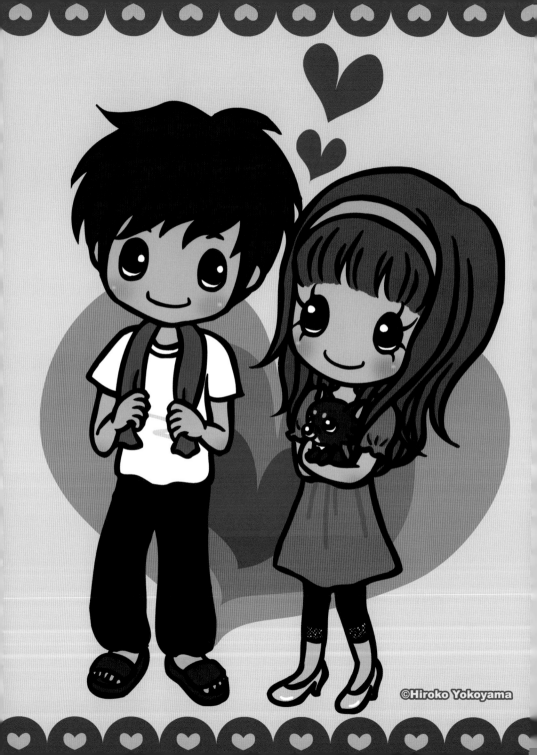

©Hiroko Yokoyama

www.yokoyama-hiroko.com

In the words of Hiroko Yokohama, the self-taught Japanese illustrator, the driving force behind her creations is to think about what makes people happy. Happiness—this is exactly what I felt when I came across Hiroko's Web site whilst making one of my habitual kawaii excursions. Her illustrations generate this feeling of well-being, something that is achieved by only the finest kawaii artists. Her style is extremely feminine and the quality of her illustrations is exceptional; the finish and the use of color are absolutely impeccable.

HIROKO YOKOYAMA
Kagawa, Japan
www.yokoyama-hiroko.com
hirorin@yokoyama-hiroko.com

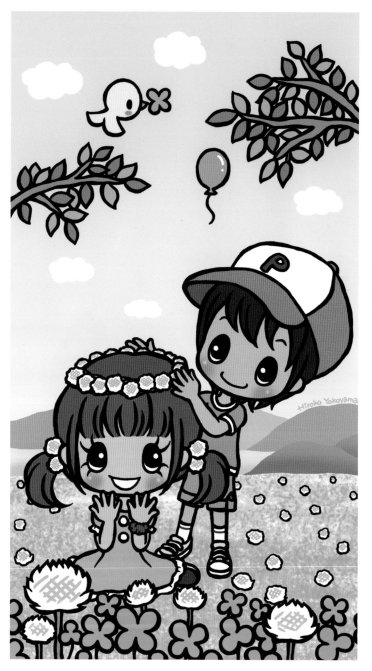

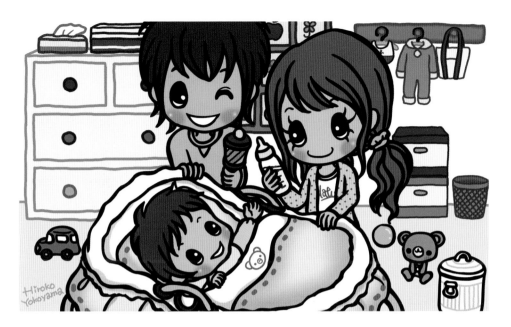

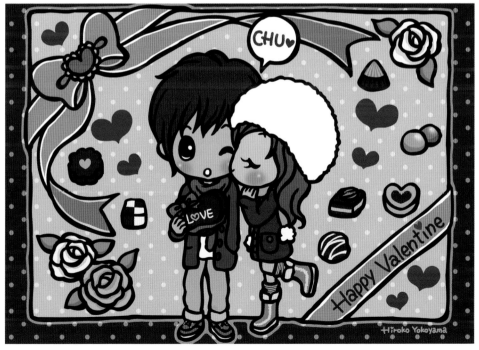

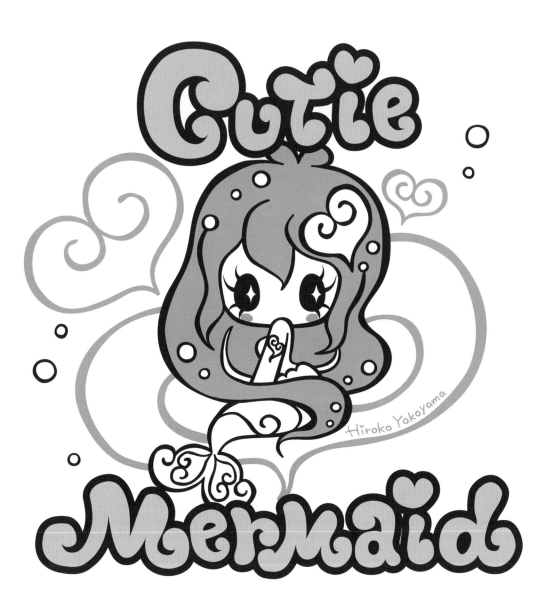

Hiroko Yokoyama

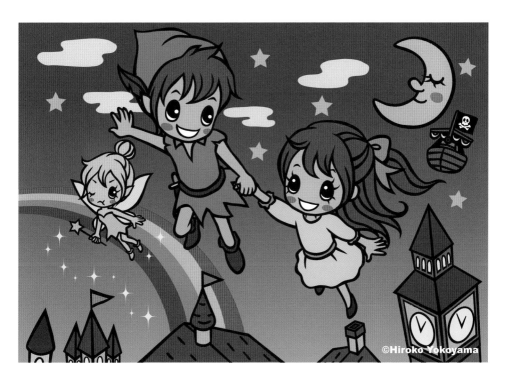

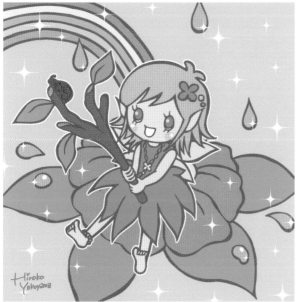

p62
CUTIE MERMAID

p63
I AM PETER PAN

THE RAINBOW THAT RAIN RAISES

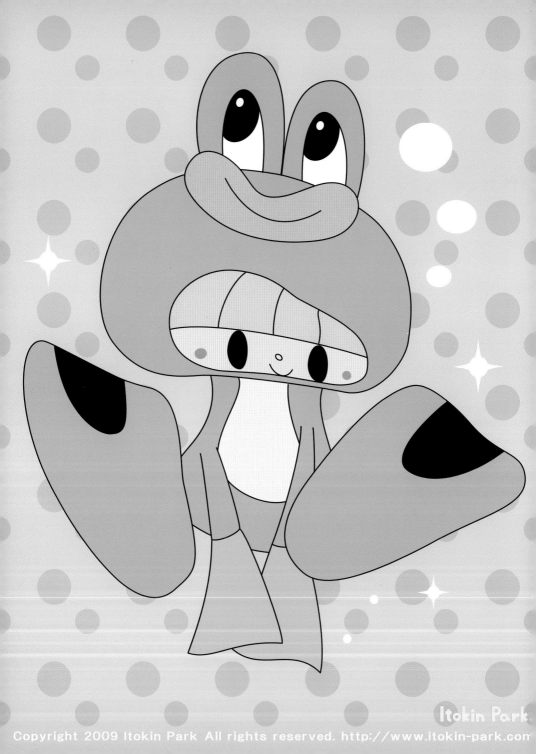

Itokin Park

Itokin Park©

I came across the work of Kazuhiko Ito, otherwise known as Itokin Park, thanks to a collection of Fimo dolls I discovered on the Internet. What struck me about her work was the juxtaposition of modern and retro design, which Kazuhiko applies to all of her characters, together with their soft and asymmetrical shapes. After this set of dolls, many others followed, which have achieved international fame. Her little characters stand out for their excellent artistic appeal. Itokin Park produces limited editions of pieces, which are extremely difficult to get hold of, much to the delight of the most fervent collectors.

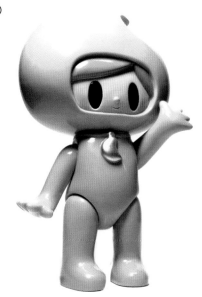

ITOKIN PARK
Japan
www.itokin-park.com
kazuhiko@itokin-park.com

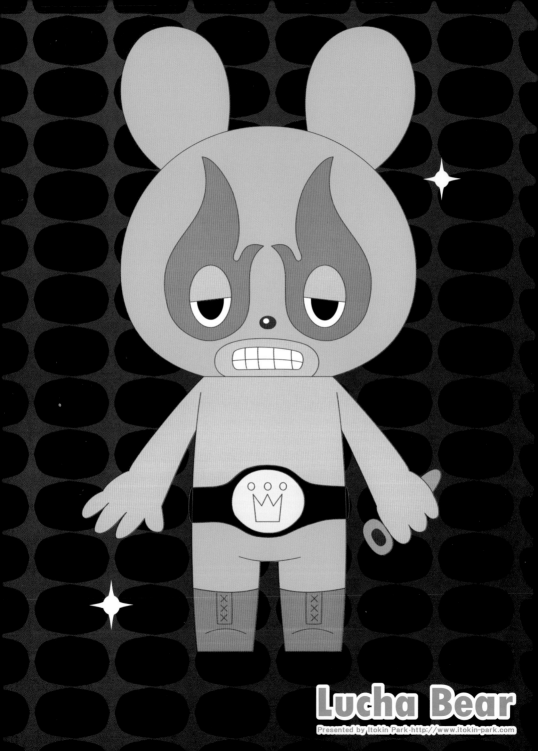

Lucha Bear

Presented by Itokin Park·http://www.itokin-park.com

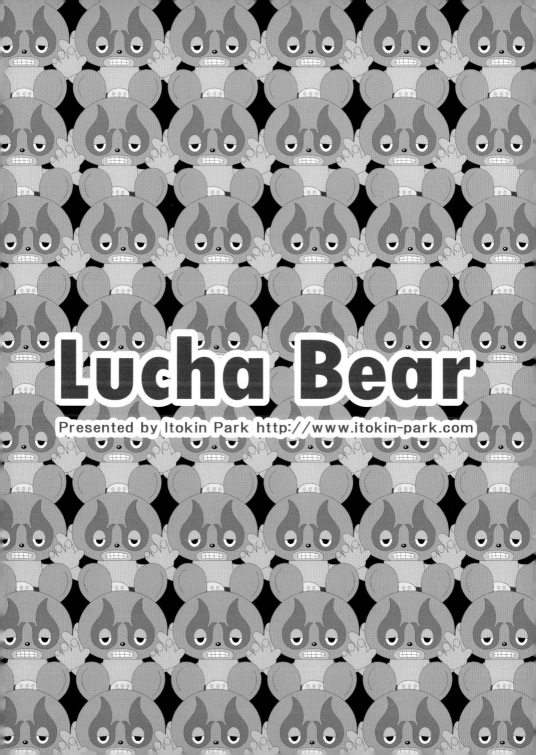

Lucha Bear

Presented by Itokin Park http://www.itokin-park.com

LAURA OSORNO

www. lauraosorno. net

Laura Osorno is a well-known Columbian artist living in New York City, where she is currently fulfilling her dream of creating characters, clothing, accessories, and all types of lovely, kawaii-oriented products. She has a very individual style: naive illustrations with an extremely bright color palette and clean lines. I myself was moved by all of Laura's characters. I particularly fell in love with her drawing of a little rabbit afraid to go out on the street. The fact is that in Laura's world nothing is as simple as it looks.

LAURA OSORNO
Colombia
www.lauraosorno.net
lauraosorno@gmail.com

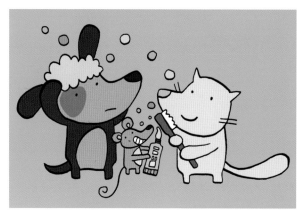

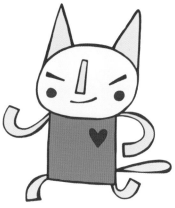

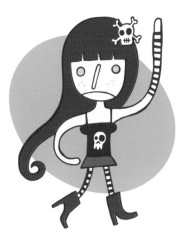

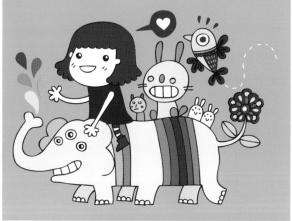

p70
ROBE, LOLA AND MAX
Illustration for *MDI* magazine

MY EYES ADORE YOU
Personal artwork

TEENAGER

CHARACTERS STUDY
Personal artwork

MIA
Personal artwork

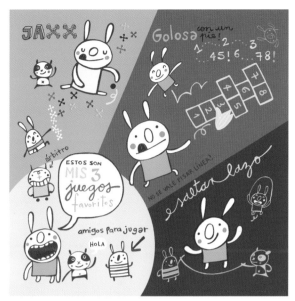

p71
MIS 3 JUEGOS FAVORITOS
Published in a collective magazine

I LOVE JAPAN
Personal artwork

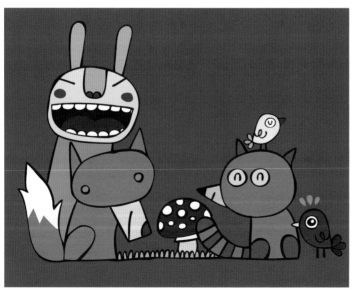

p72
CHARACTERS STUDY A
Personal artwork

CHARACTERS STUDY B
Personal artwork

p73
SUPERMERCADO
Published in a collective magazine

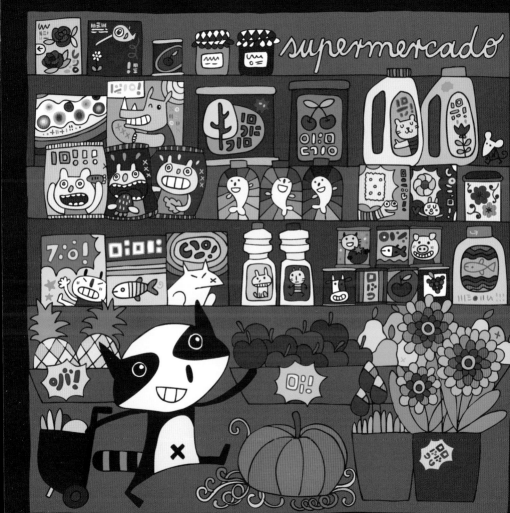

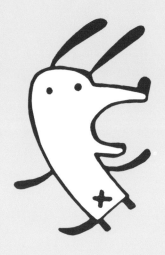

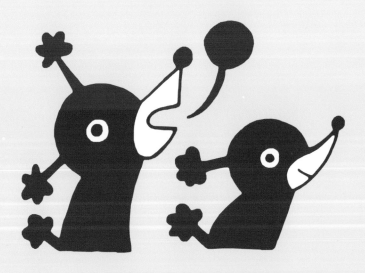

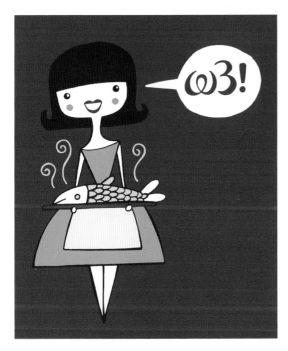

p74
HEY!
Personal artwork

p75
OMEGA 3

NIÑA PULPO
Record cover

MEETING THE PARENTS

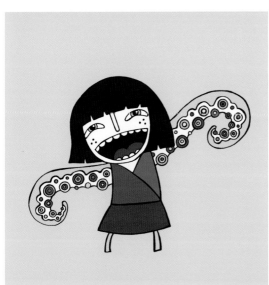

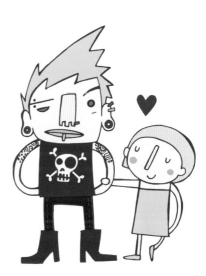

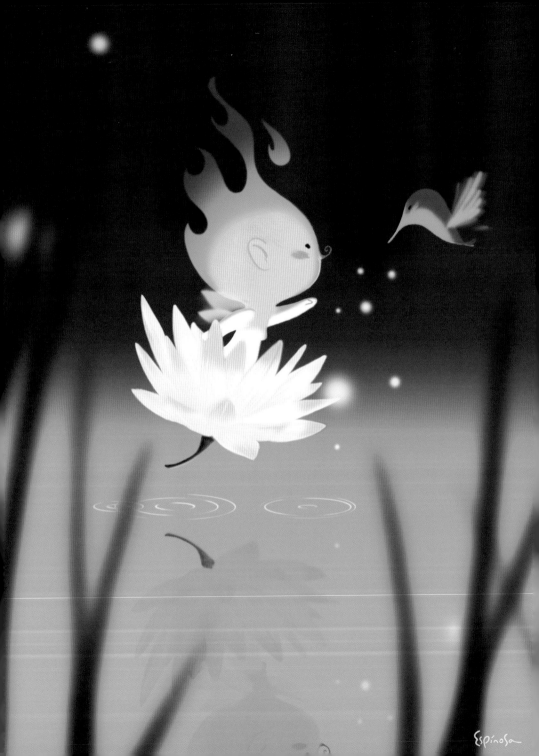

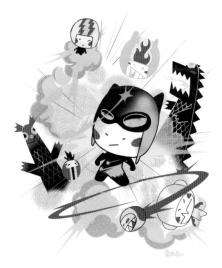

Leo Espinosa is a Colombian artist currently living in Cambridge, Massachusetts. Most of his kawaii illustrations have a highly personal style, a certain sweetness that only a person with Leo's sensitivity is capable of achieving. My favorite characters are Otis and Rae. The design, the shapes, and the choice of colors simply drive me crazy. The composition is highly entertaining. Leo combines his artistic projects with more commercial projects, such the animation for Sushi Pack and various publicity campaigns or incursions in the licensing world, such as the wide range of products he has jointly created with Coca-Cola.

LEO ESPINOSA
Cambridge, USA
www.studioespinosa.com
leo@studioespinosa.com

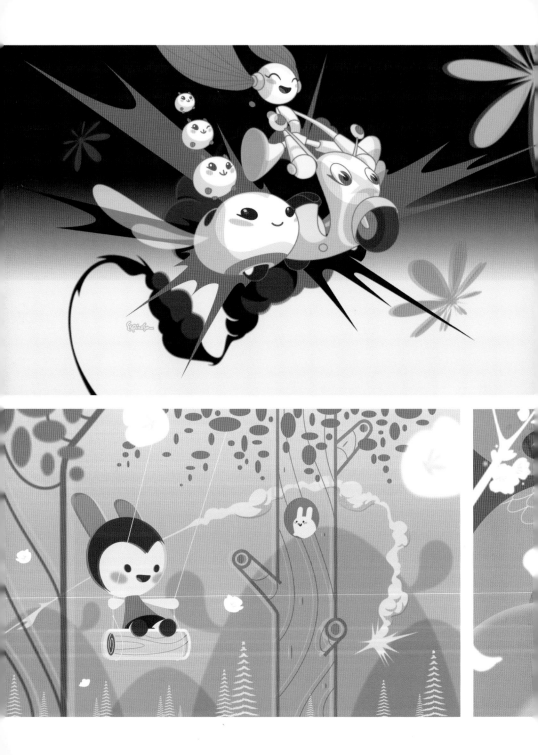

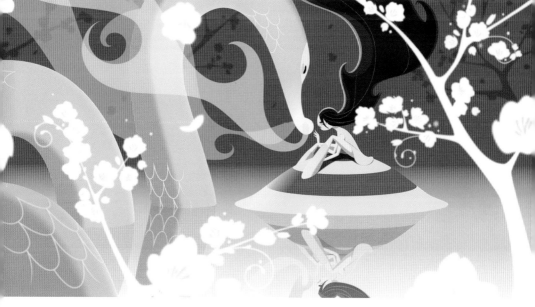

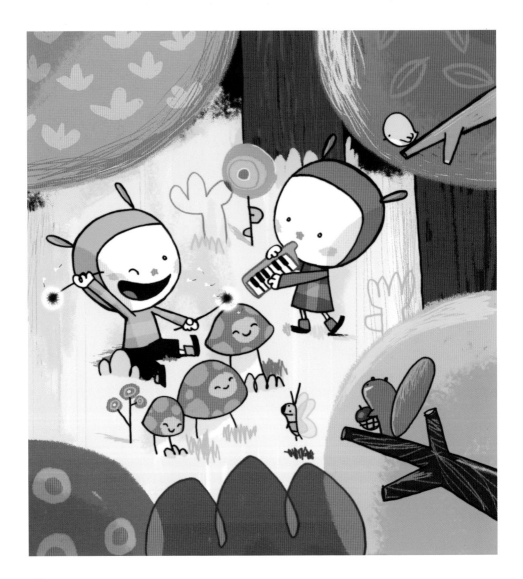

p80
OTIS AND RAE
Design and development for a multi-platform property
launched as a children's book titled *Otis and Rae and the Grumbling Splunk*

p81
DICEKAY
Opener for the sports section of the *Boston Globe* welcoming
Daisuke Matsuzaka, aka Dice-Kay, to the Boston Red Sox baseball team

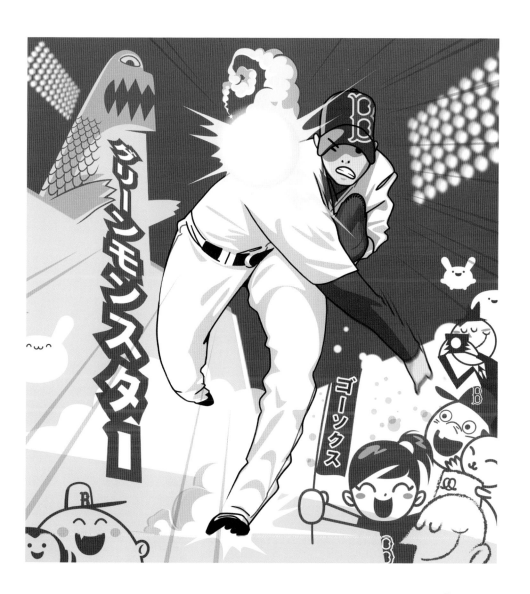

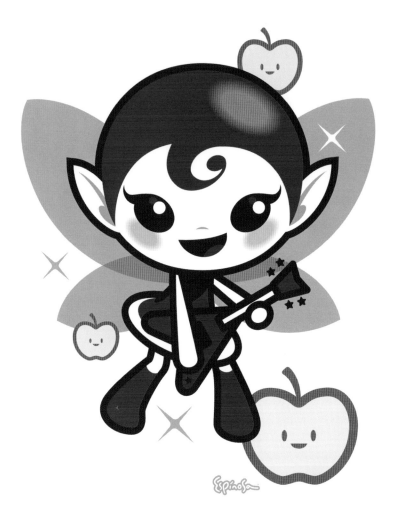

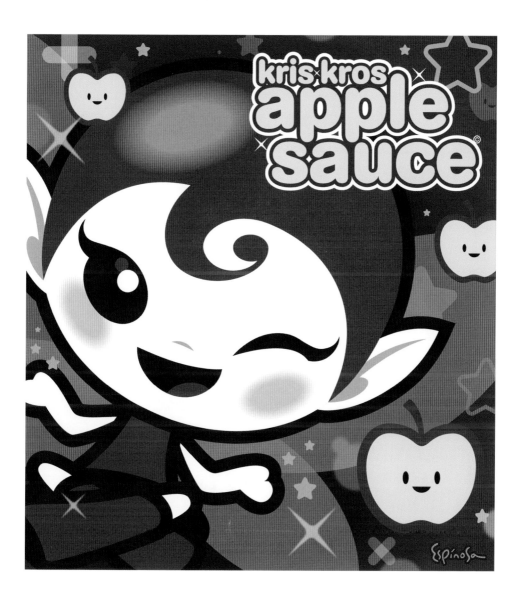

p82–83
KRIS KROS APPLESAUCE
Character and product design
for a licensing property

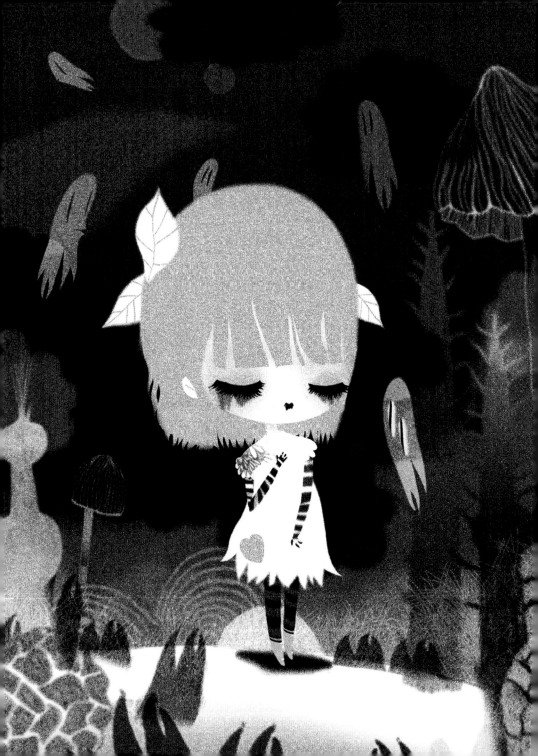

p84
SNOW WHITE

p85
T-shirt design

LiLiDOLL.COM

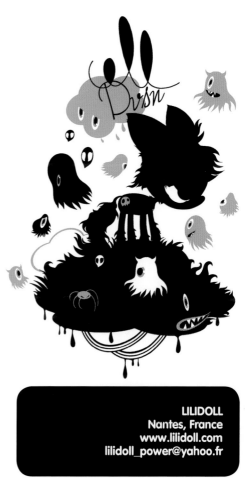

Lilidoll is a Parisian artist whose sweet and splendid illustrations I find enchanting. Lilidoll characters appear innocent at first glance, but anyone who takes a little time to delve inside their world will discover that there is a dark power behind these stubborn, retro-like creatures. I just love the Lilidoll figures; not only is Lilidoll's attention to detail evident, but so is the care she takes to create them. Aside from her work in advertising and publications, native and foreign, Lilidoll also merchandises T-shirts, dolls, and all sorts of desirable objects.

LILIDOLL
Nantes, France
www.lilidoll.com
lilidoll_power@yahoo.fr

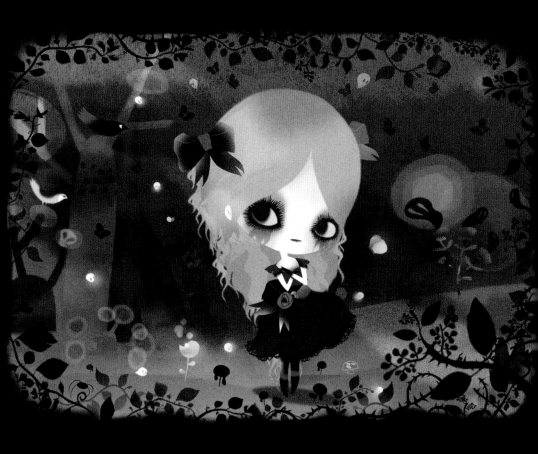

p86
THORN FOREST

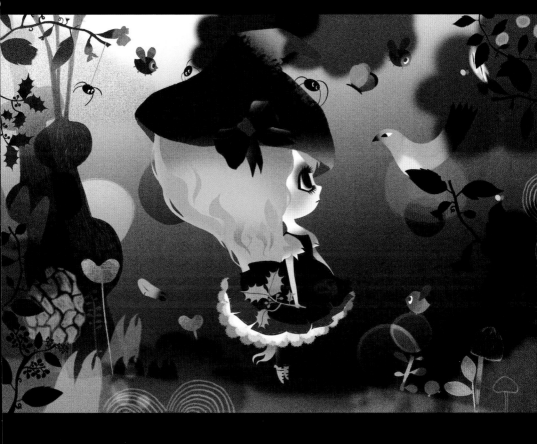

p87
GREEN BIRD

p88
MINA

p89
CHARACTER BORARD

JE GRIBOUILLE AU JARDIN
Coloring diary (stationery)
for La Marelle Publisher (cover)

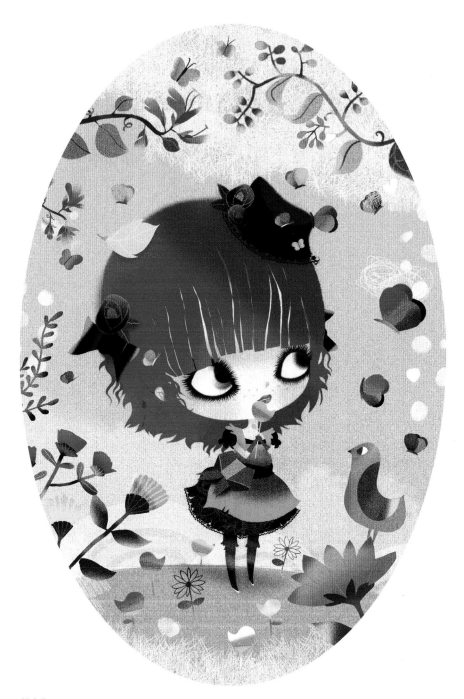

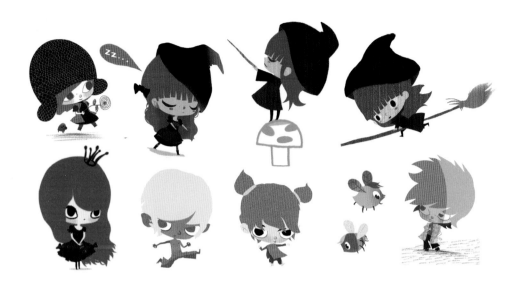

je gribouille
au jardin

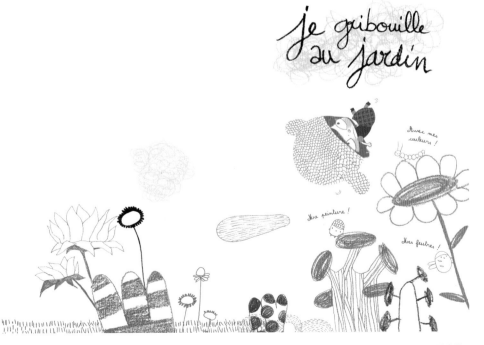

Avec mes
couleurs !

Ma peinture !

Mes feutres !

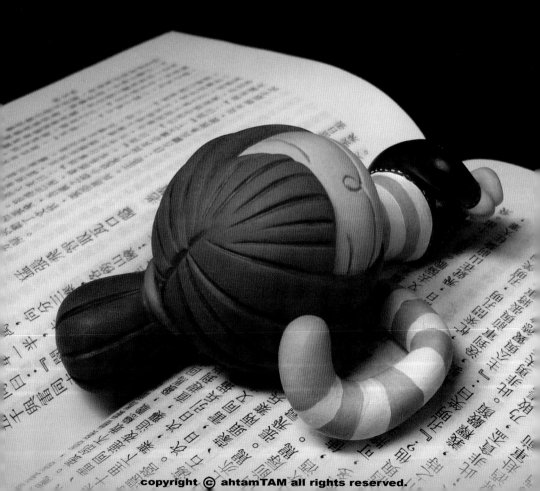

little ★ Amie

BORINGGGGGG ...

ahtam ♥ TAM

It was in Atticus BCN, one of Barcelona's best toyshops, where I first came across a piece by Little Amie. I was astonished by the infinite sweetness of one character in particular, who was sleeping in a cup. I found myself being careful not to wake her. I arrived home determined to learn more about the creator and this was how I got to know about Little Amie's world. I discovered that hidden behind this name there was an artist who lived in Hong Kong. Nature, animals, and the unexpected achievements in everyday life are her source of inspiration. Her philosophy is to create dreams and provide beauty in a world that clearly needs it.

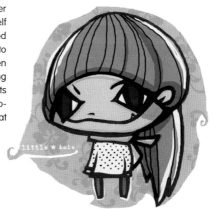

LITTLE AMIE
Hong Kong
www.little-amie.com
ahtam.tam@gmail.com

p92
LITTLE AMIE DOODLE

p92–93
Designs for Megabox box

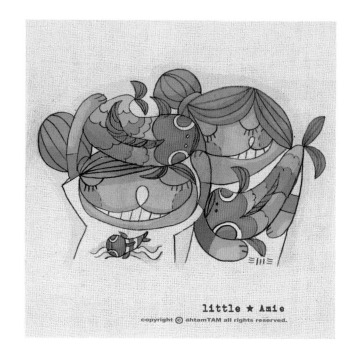

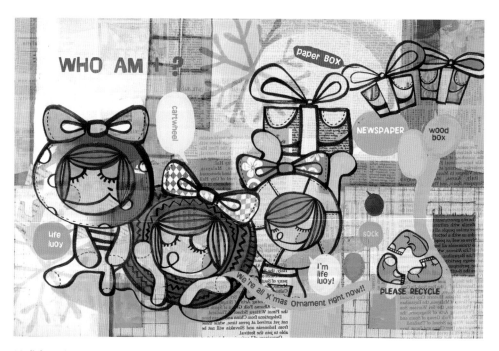

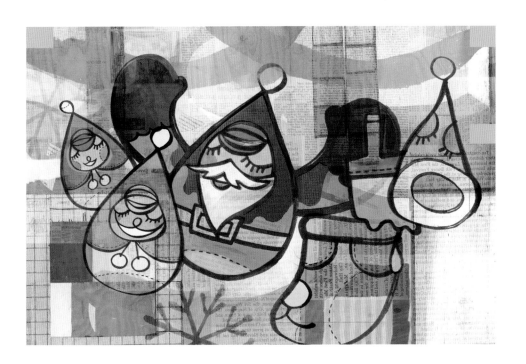

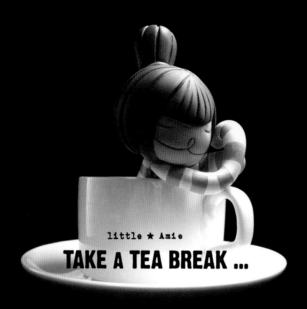

little ★ Amie

TAKE A TEA BREAK ...

p94
"LITTLE-AMIE" FIGURE

p95
"AMIE-RABBIT" FIGURE

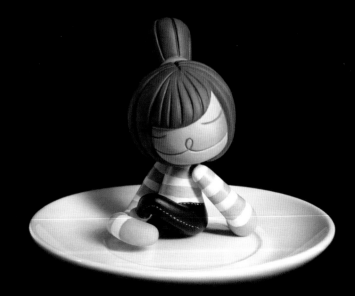

Little ★ Amie

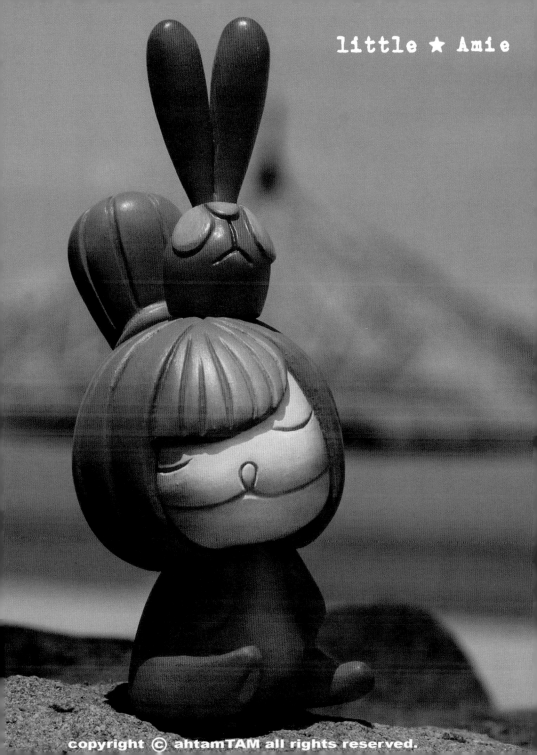

little ★ Amie

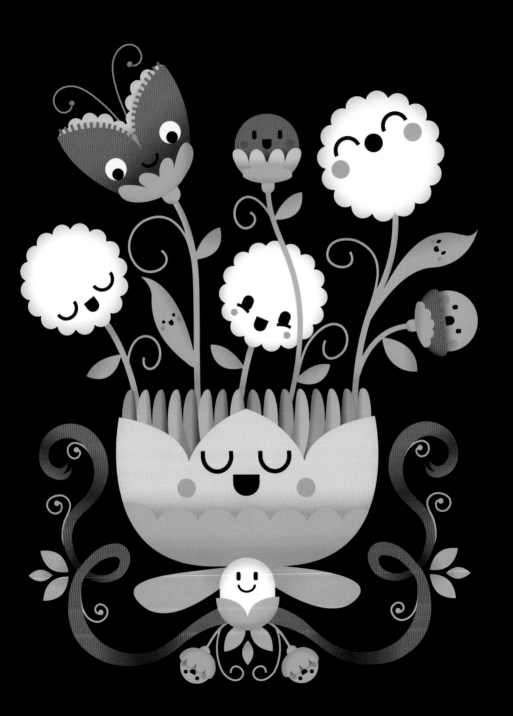

LOULOU & TUMMIE

LouLou & Tummie is a Dutch illustration studio that aims to expand its empire of characters and multicolored graphics. They create whole kawaii-inspired worlds and illustrations for magazines, books, advertising, and interiors. Their art can appear as decorative wall designs or in the form of adorable soft dolls and accessories. They have just brought out The Tummie Friends, a brand of adorable products launched at the Taipei Toy Festival.

LOULOU & TUMMIE
Tilburg, The Netherlands
www.loulouandtummie.com
info@loulouandtummie.com

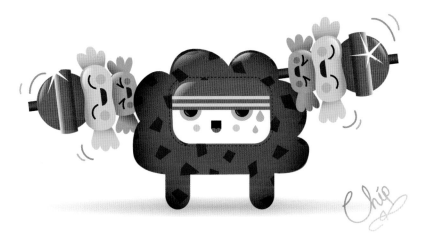

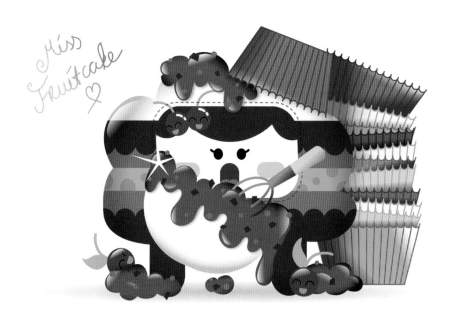

Miss
Fruitcake ♡

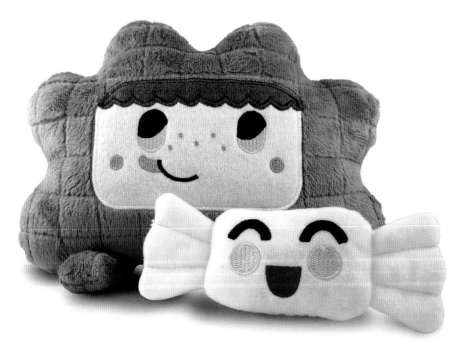

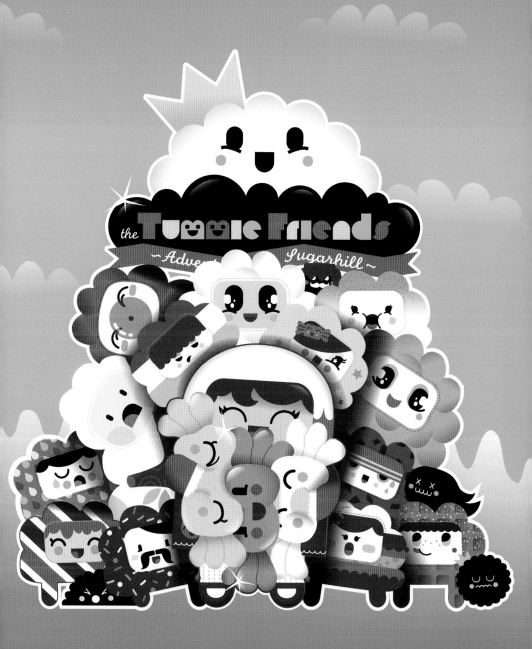

p100
SATURDAY NIGHT MARI-CHAN

p101
MARI-CHAN
Charcater design

CHARACTERS

MARI-CHAN

Mari Chan was one of the first kawaii artists I came across. It was way back in 2002 when little Terelo provided me with a Web link that opened the door to the world of Masanori Handa, otherwise known as Mari Chan. Born in Osaka, Japan, Mari says it is her intention to express her feelings through her work. Despite their sometimes serious outward manner, the Japanese are full of happy surprises, as Mari herself proves. Her world is bold and playful and devoid of any sense of artistic restriction.

MARI-CHAN
Tokyo, Japan
www.marichan.com
marichanps@gmail.com

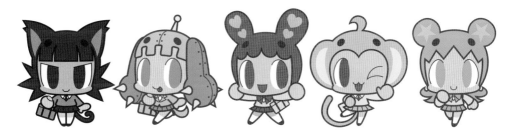

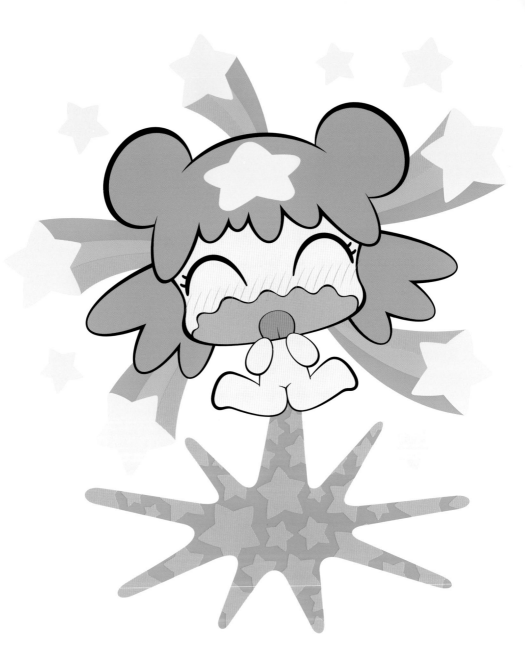

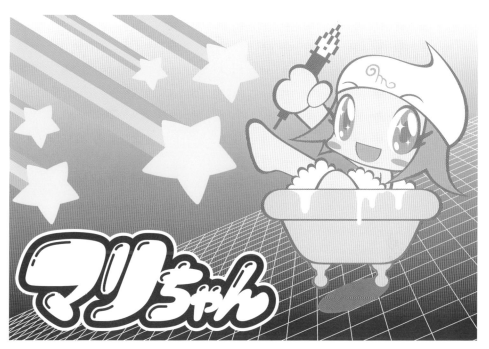

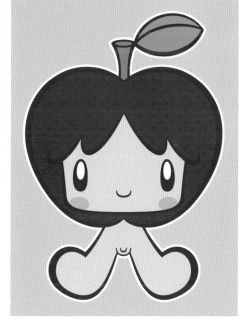

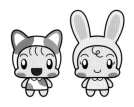

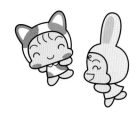

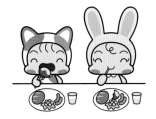

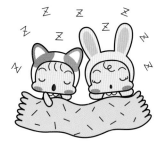

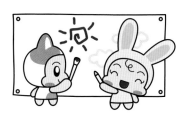

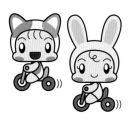

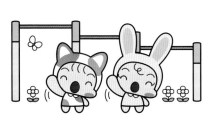

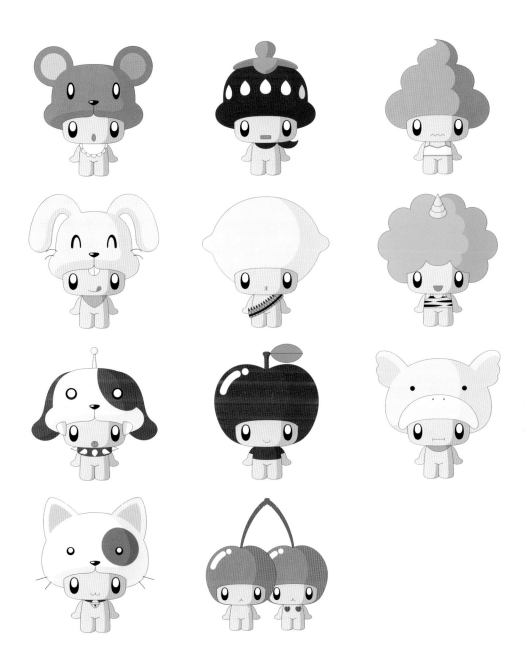

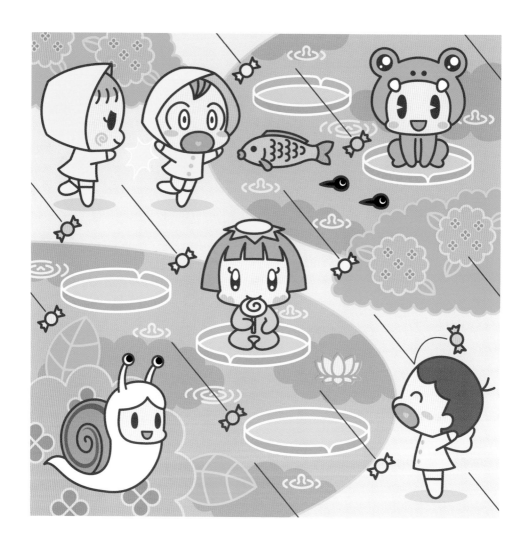

p102
BIKKURI BANG

p103
POSTCARDS

p104–105
CHARACTERS

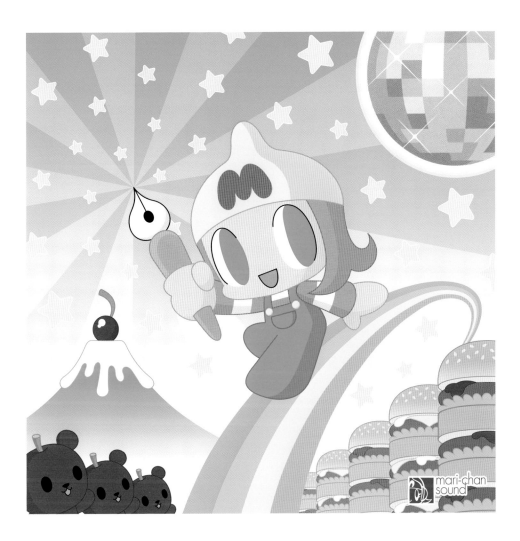

p106
RAINY SEASON

p107
MARI-CHAN THEME

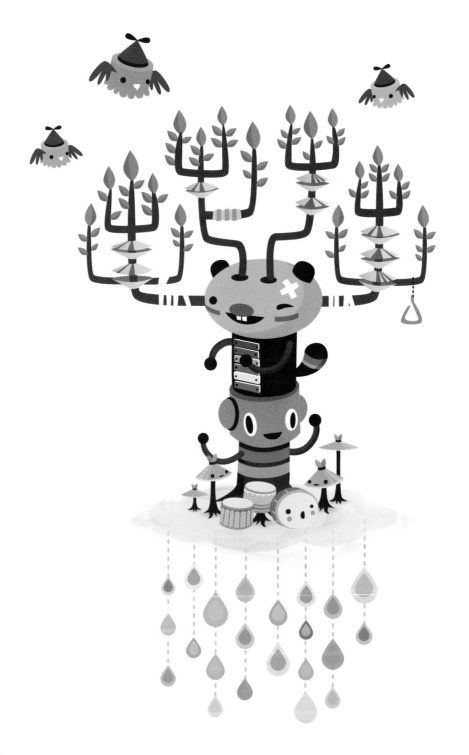

meomi

www.meomi.com

Meomi is the dream factory created by Vancouver-based
Vicki Wong and L.A.-based Michael Murphy. Their work has
been reviewed in countless books, design magazines, and
e-zines. Their graphics are super sweet and include every-
thing from simple compositions to extremely elaborate and
highly detailed works. And, as if this weren't enough, these
artists are completely committed to spreading kawaii around
the world. They were responsible for designing the adorable
mascots for the Vancouver 2010 Olympic Games and regu-
larly publish illustrated books for both children and adults.

MEOMI
Vancouver, Canada
www.meomi.com
info@meomi.com

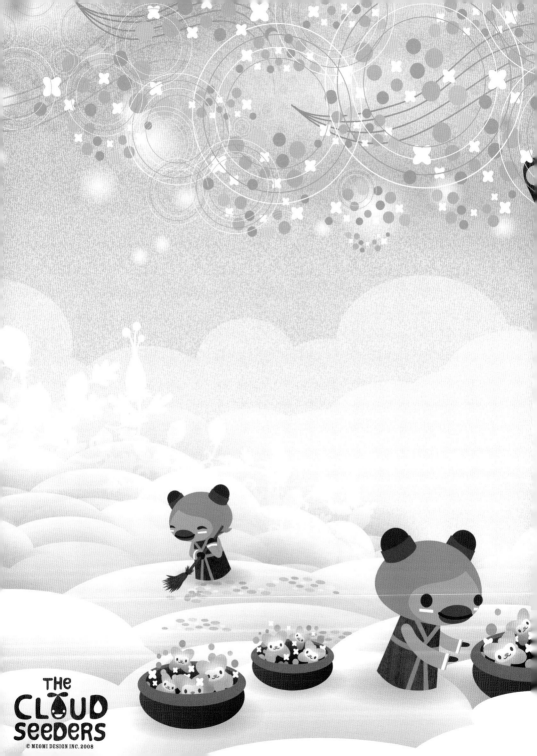

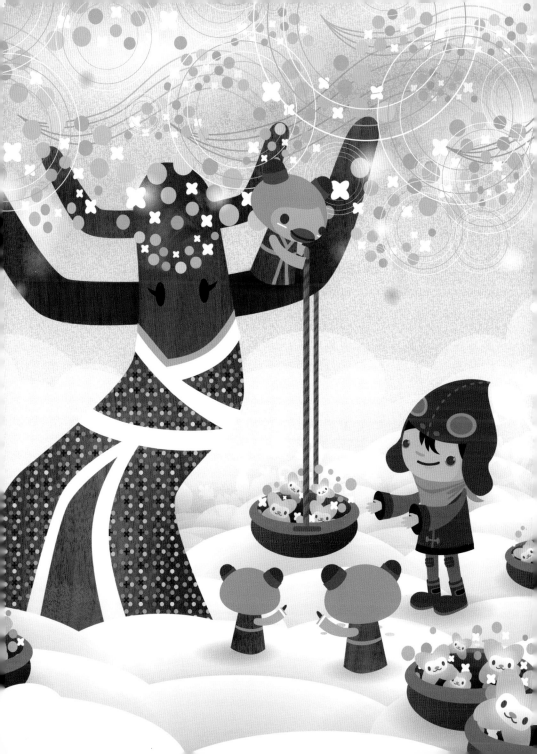

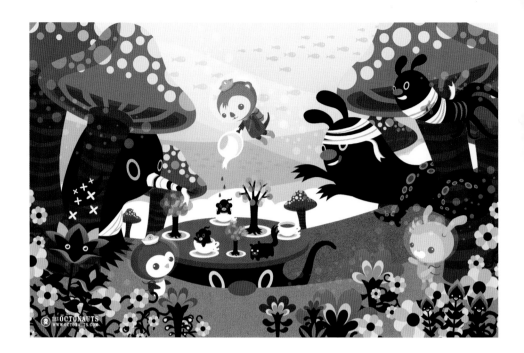

p112
SHADY TEA

p113
JELLY FISH

p114–115
SUMMER

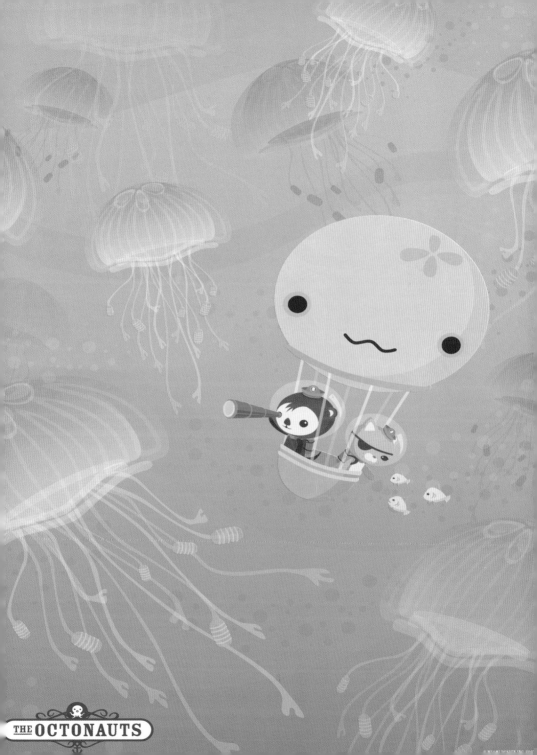

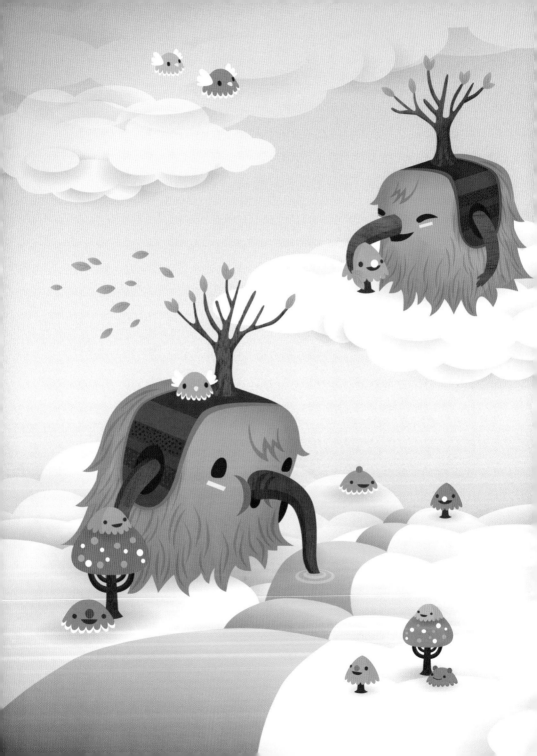

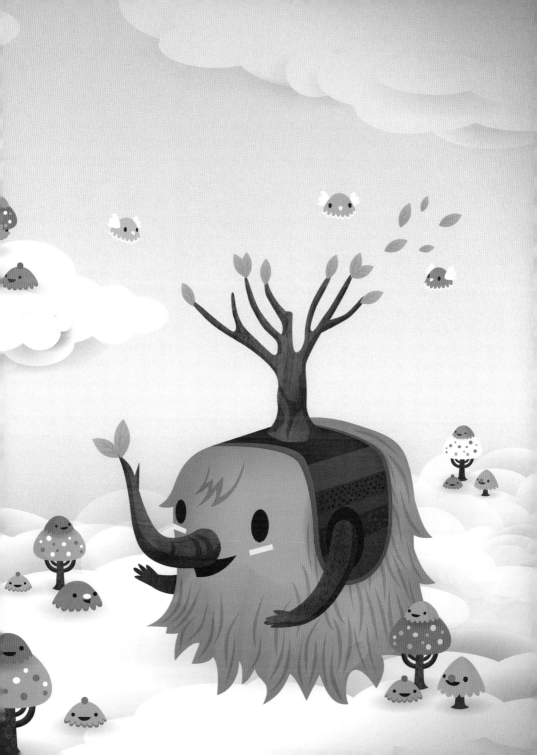

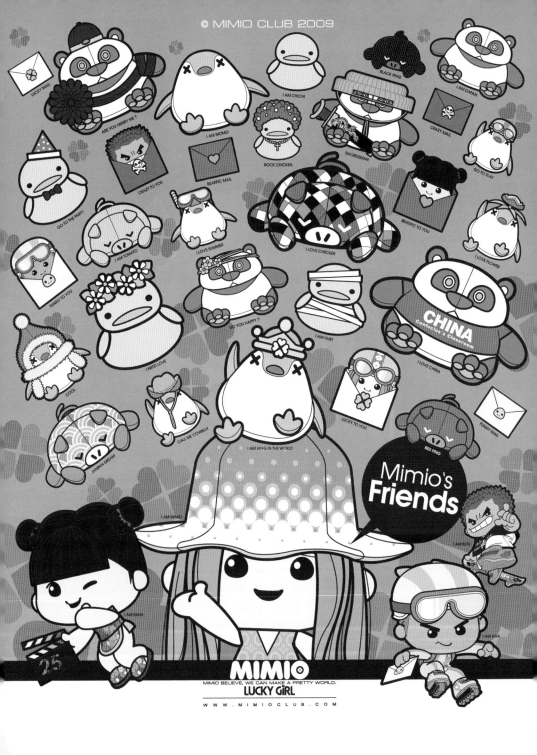

MIMIO BELIEVE, WE CAN MAKE A PRETTY WORLD.

LUCKY GiRL ——— WWW.MIMIOCLUB.COM

Maxpipi believes that we can build a beautiful world. Mimio is the name of the main character on the Web by Maxpipi, an artist resident in Taipei, Taiwan. Her work is simply impeccable. Maxpipi completely masters the art of kawaii illustration. Her vectors are perfect. Mimio exists alongside other incredibly sweet characters such as Aha, Elfu, and Mani, and, as if this weren't enough, each one has its own mascot. It's a kawaii paradise.

MAXPIPI
Taipei, Taiwan
www.mimioclub.com
pipi@mimioclub.com

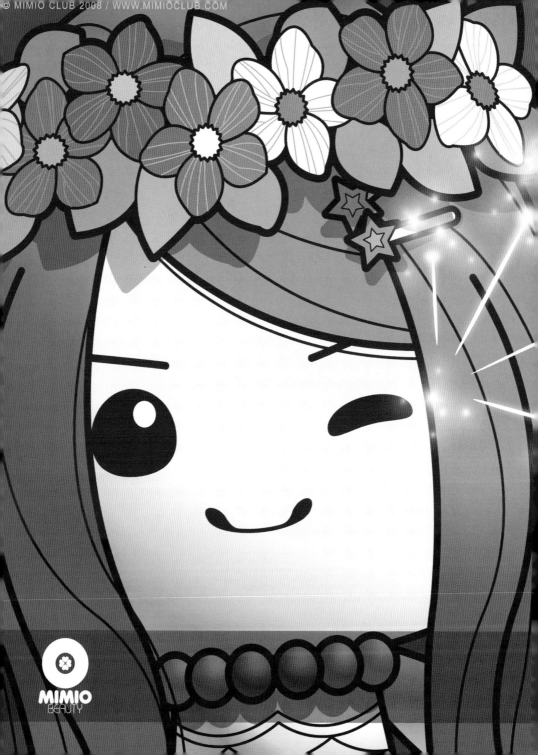

MIMIO
BEAUTY

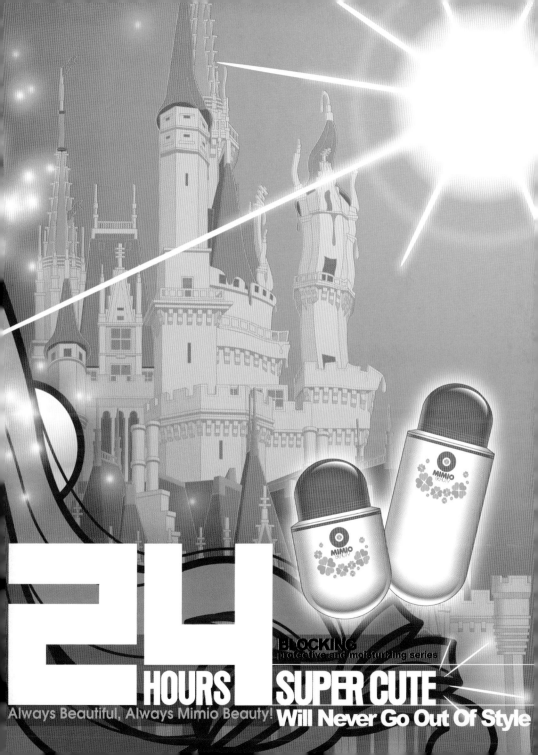

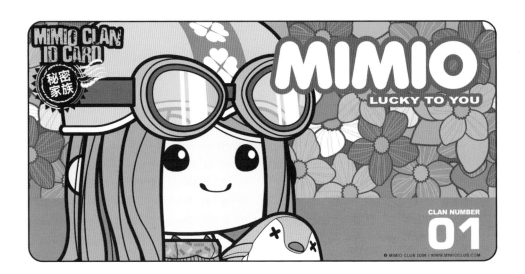

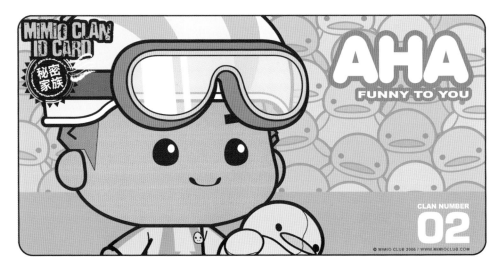

p118–119
MIMIO MAGAZINE CONTENTS
Brand image advertisement in a magazine
concerning a fictitious cosmetic brand

p120
MIMIO AND MOMO

AHA AND CHICHI

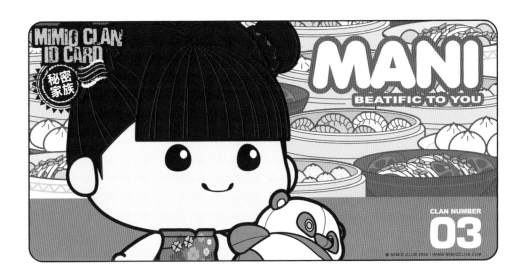

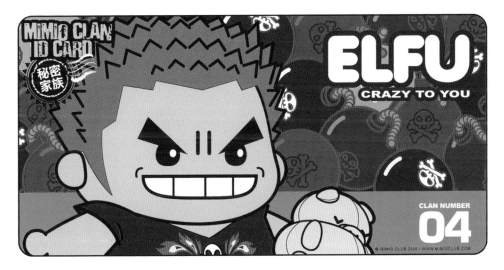

p121
MANI AND DAPAN

ELFU AND TOMATO

roporopo

pouly*

I am pouly. I am piggy.
I like beautiful, lovely things.

mizuka

We return to the land of the rising sun to present the intricate work of this Tokyo-based artist. Mizuka began as a freelance illustrator in 2006, specializing in the design of little animals and kawaii characters. As is usually the case with Japanese artists, Mizuka has created a unique line of illustrated objects and has also published children's books. I just love the way she makes use of retro-like aesthetics from the 1950s and 1960s. She is one of the few Japanese artists who has distanced themselves from the classic kawaii to adopt a more Western approach.

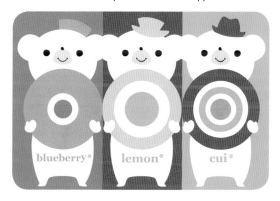

blueberry* lemon* cui*

MIZUKA
Tokyo, Japan
www.mizuka-web.com
info@mizuka-web.com

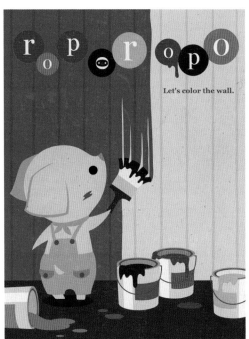

Let's color the wall.

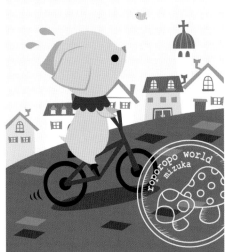

GO GO bicycle!!

There is a sky I can recommend.
The smell of the sky refreshes.

roporopo world
mizuka

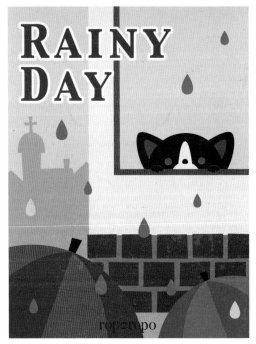

RAINY DAY

roporopo

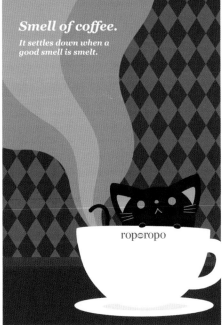

Smell of coffee.

*It settles down when a
good smell is smelt.*

roporopo

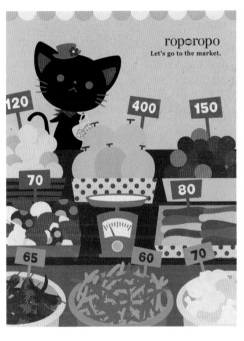

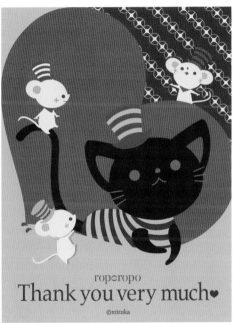

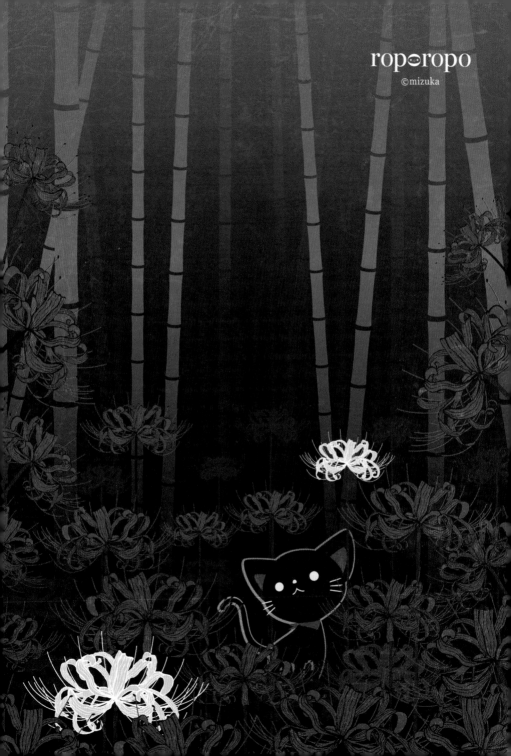

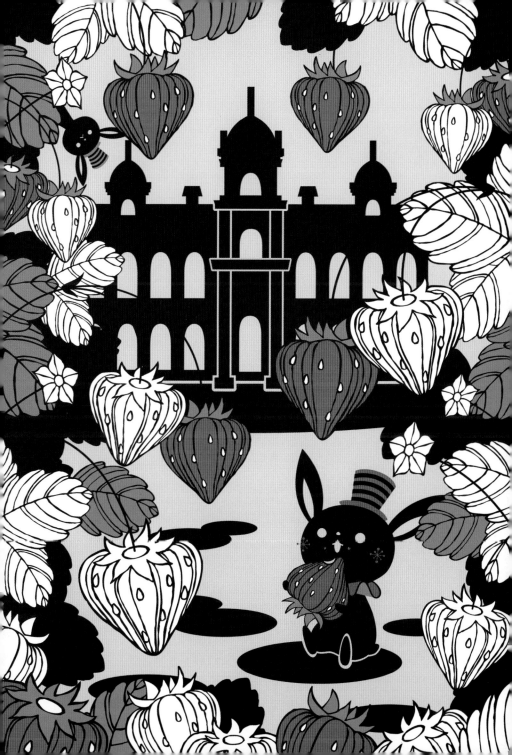

I have always been a great fan of Pablo Moreno. This illustrator, originally from La Mancha and now settled in Barcelona, Spain, is more than just a friend. Together with Pablo and whilst we were experimenting without any intention other than to enjoy ourselves on the MONDOTRENDY Web site, I discovered that my passion for illustration overrode the limits of the hobby. Pablo currently works as a freelance illustrator on projects for advertising agencies, as well as for publishers. Pablo's kawaii illustrations are adorable, sweet, and charming. His little rounded characters and his subtle sense of humor always bring a smile to my face.

PABLO MORENO
Barcelona, Spain
www.mondotrendy.com
info@mondotrendy.com

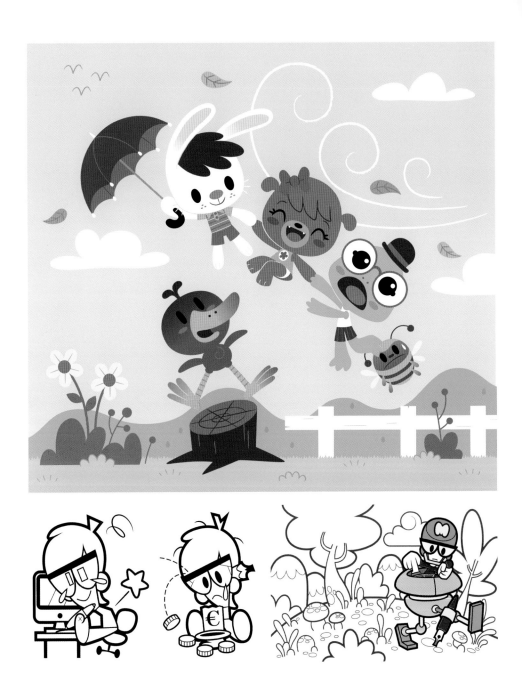

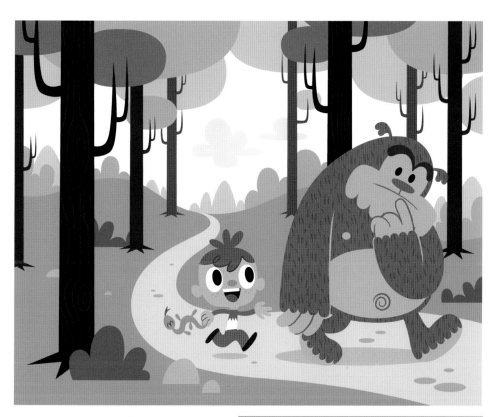

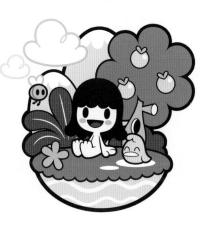

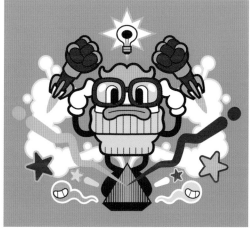

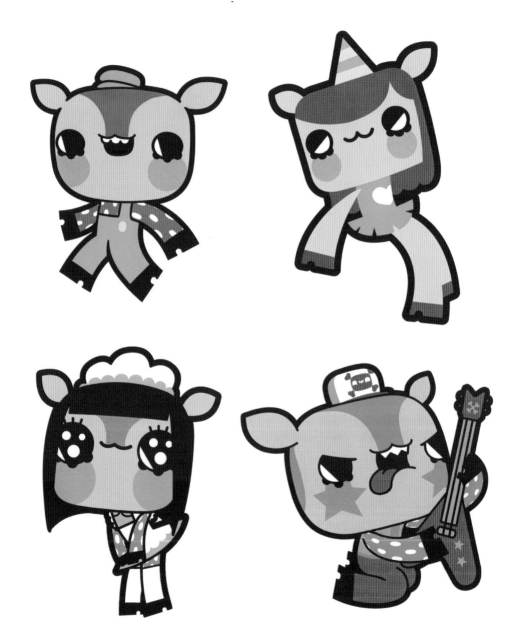

Kawaii takes us to New Zealand, home of Paul Shih, who is originally from Taiwan. What struck me about Paul (apart from the indisputable quality of his graphics) was a technique he himself developed. This one-of-a-kind technique consists of combining illustration, paper cutting, and other photography techniques. The result is artwork entirely representative of Shih's sense of style and personality. According to Paul, by day he works as a freelance designer and illustrator and by night he locks himself away in his magic laboratory to conduct experiments with his creatures. He believes that one day his nocturnal characters will invade the earth. I'm convinced of it.

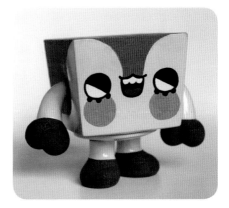

PAUL SHIH
Auckland, New Zealand
www.paul-shih.com
paul@paul-shih.com

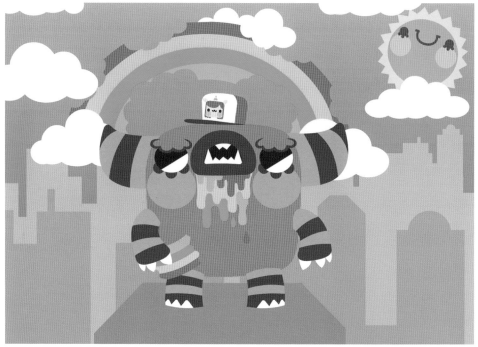

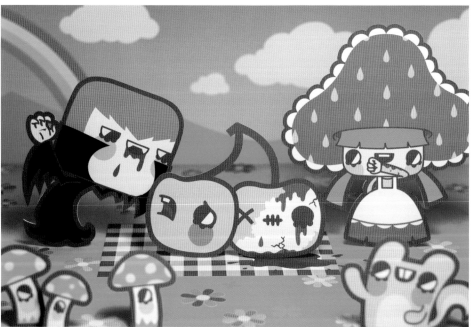

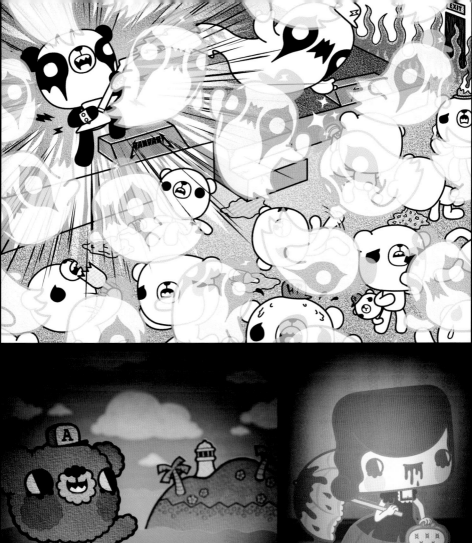
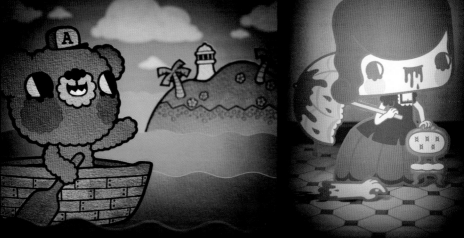

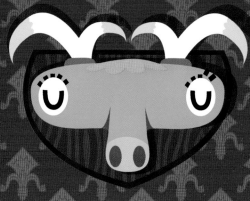

MR SNOUT

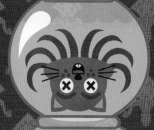

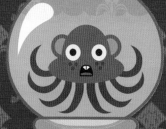

FABIAN

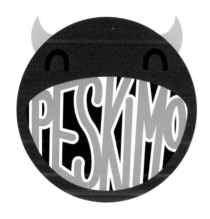

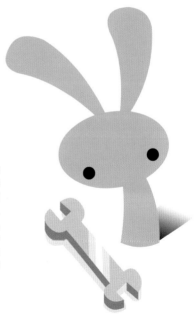

Peskimo is 50 percent by Jodie and 50 percent by David. They have been jointly creating creatures from Bristol, UK. Their characters have come into the world in the form of toys, animations, publicity products, and clothing for such as Kidrobot, Sony, Barclays, and Vodafone. Their inspiration comes from cartoons, vintage graphic design, chocolate, and spying on people at the post office. Their dream? To one day own an ice cream van.

PESKIMO
Bristol, United Kingdom
www.peskimo.com
go@peskimo.com

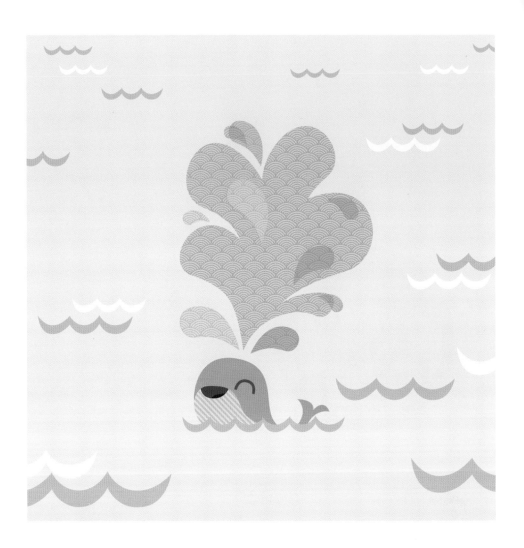

p138
SPLASH
Illustration for Moo.com

p139
VARIOUS CHARACTERS

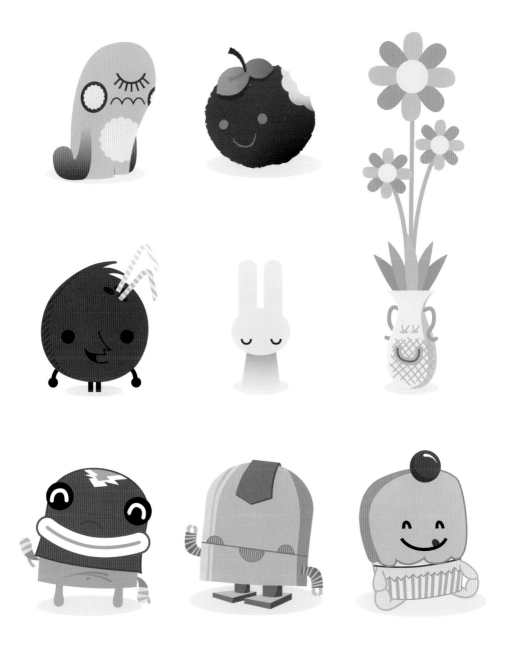

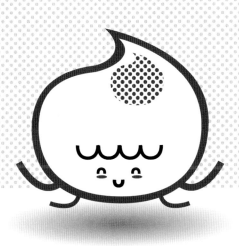

p140
STEREO LOVE
Illustrated pattern

p141
HAPPY DROP AND SAD DROP
Illustrations for Moo.com

BUNNY BREATH - PREQUEL
Limited Gocco print for Kidrobot Dunny launch

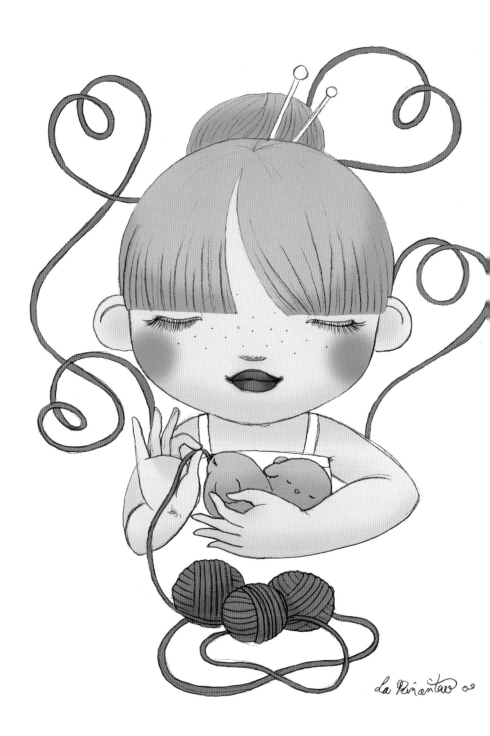

p142
SUAVES COMO LA LANA
Pencil and Photoshop

p143
VERANO
Watercolor and ink

p144–145
BLACK & WHITE
Digital vector

Princesita is María Carrasco's alter ego. She was born in Málaga, Spain, in 1983 and, influenced by the stories her mother used to make up for her and her sisters, one day decided to be a princess and to create her own special world around her—a world where the girls come with curves, where color is fundamental, and where a free rein is given to anyone with the prettiest shoes. María is a hyperactive multidisciplinary artist, who exudes art through and through, in everything she does—from illustrations to the creation of a felt or fimo toy, slippers, or pretty little cakes.

LA PRINCESITA
Malaga, Spain
princesitastyle.com
laprincesita@princesitastyle.com

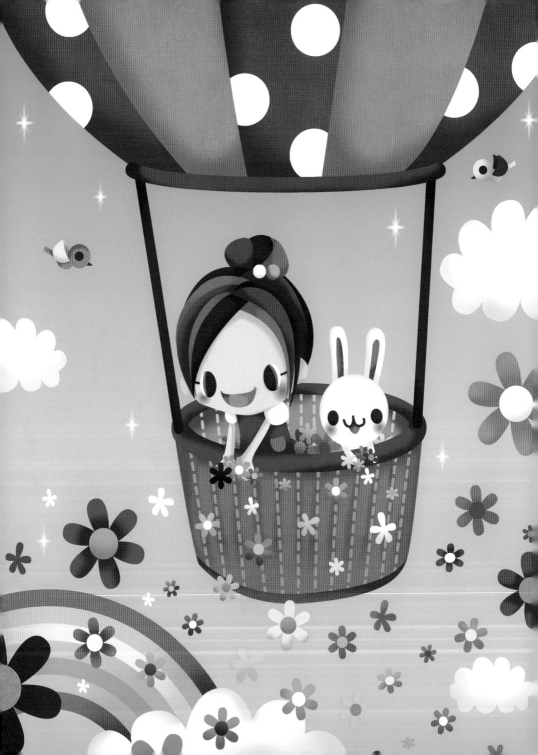

Ryoko is a Japanese artist living in Tokyo. She works as a freelance illustrator, and has also been developing her own kawaii-inspired world—a colorful place that abounds with unlimited happiness. Ryoka creates her own illustrated stories, which she also publishes. Her most artistic work consists of creating appealing graphics inspired by dreams. Her style is supercute and designed to make people happy. Her illustrations have recently been shown at the Artcomplex Center in Tokyo, Japan.

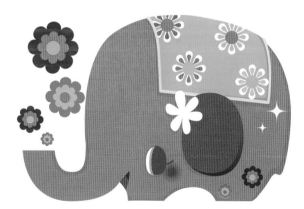

RYOKO
Tokyo, Japan
ryokooekaki.ciao.jp
ryoko-rk@excite.co.jp

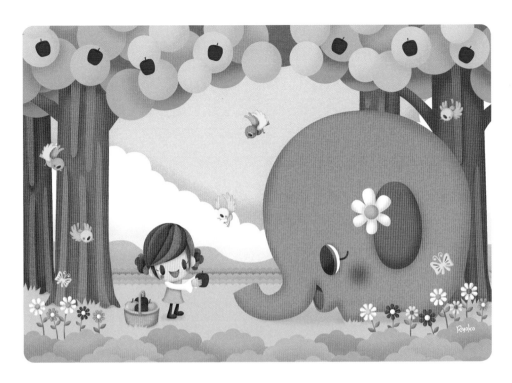

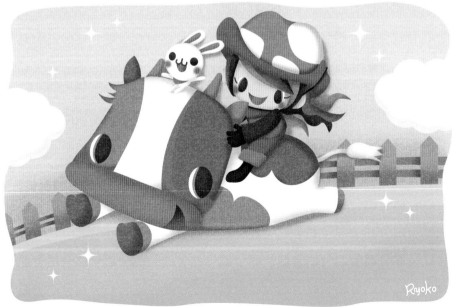

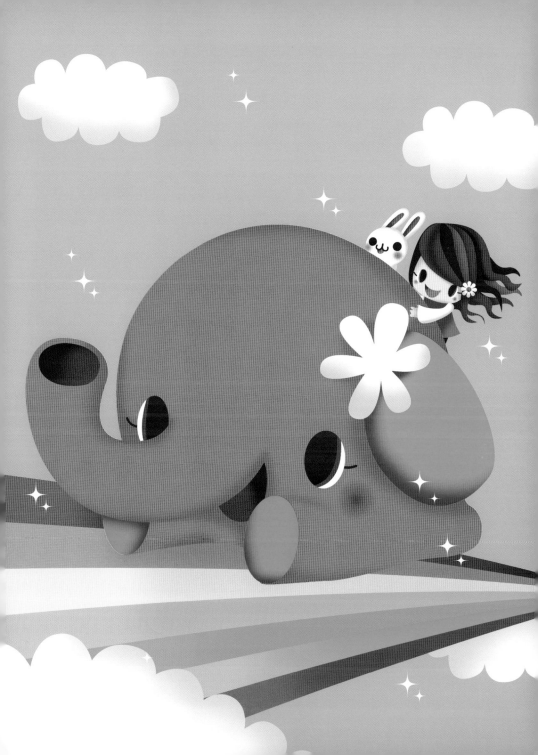

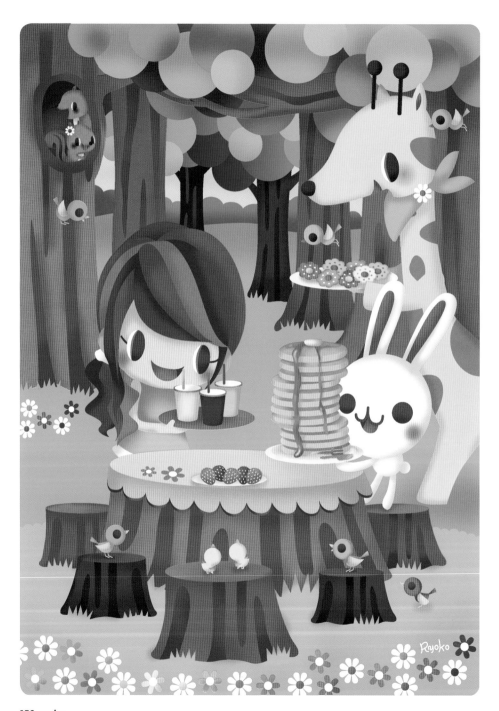

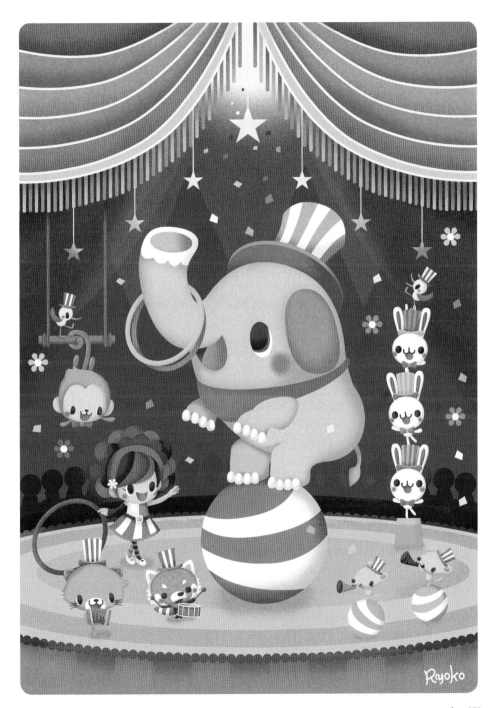

ryoko 151

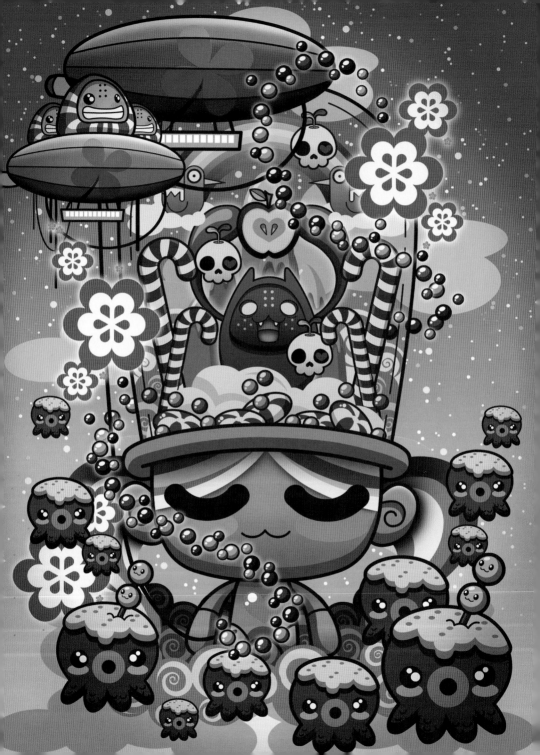

Sheena Aw, otherwise known as Caramelaw, is a designer/illustrator from Singapore, China. Sheena specializes in motion graphics and her work includes designs for MTV Asia and Sony International. In 2005, she won a Promax Award for one of her promotions for MTV Asia. Her digital kawaii creations have made her well known all around the world. Sheena herself says if there's one thing she gets excited about it is being immersed in her world of sweets, rainbows, and mushrooms—a world of baroque kawaii compositions created entirely in vector mode.

SHEENA AW
Singapore
caramelaw.deviantart.com
mesourcream@yahoo.com

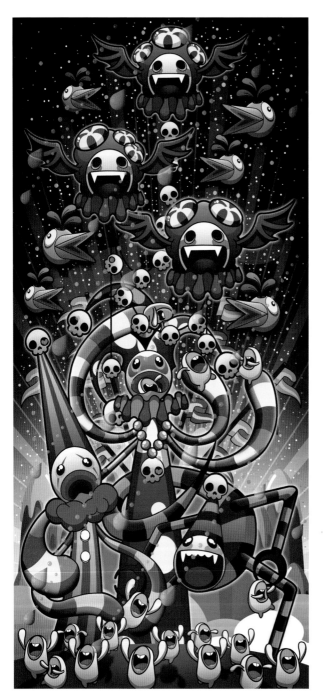

p154
DEPTHCORE HEIST

DEPTHCORE HER

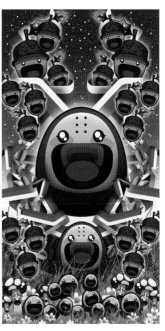

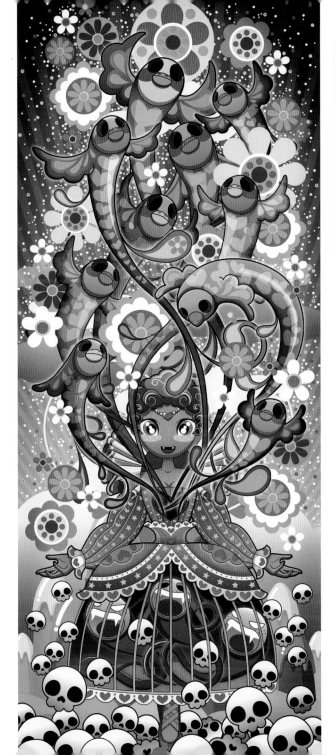

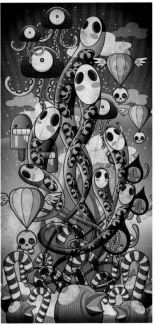

p155
DEPTHCORE MAJESTY

DEPTHCORE REQUIEM

!RESIST!
KEEP
SMILING

p156
RESIST
Poster

SUPER DEUX™

Sebastian Roux is the artist behind the brand Superdeux, which also happens to be the name of his design studio. This French artist, currently living in San Francisco, California, was one of the pioneers in working with a specific Japanese style of illustration in 2002. His style clearly has a Japanese influence; while his latest creations have a retro style language heavily dependent on graffiti culture, urban art, and electronic music. It could be said that Sebastian has had a great deal of influence on developing the most kawaii-orientated line, that of the art toy. He was certainly one of the first artists who went way beyond customizing a platform toy to have his own collection of characters, the most famous being the indisputably popular Stereotype.

SUPERDEUX
Lille, France
www.superdeux.com
info@superdeux.com

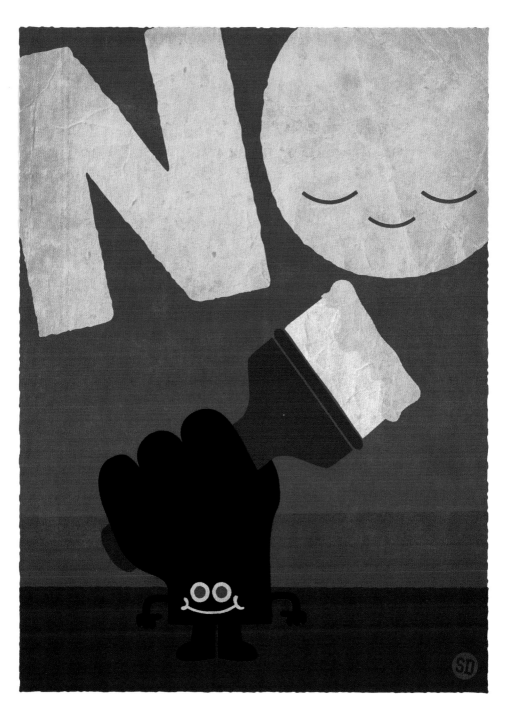

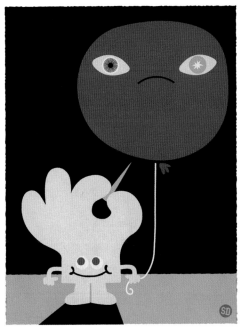

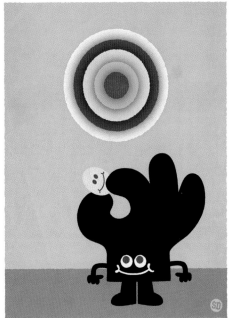

p158
MOODY SHOW 01

p159
MOODY SHOW 02

MOODY SHOW 03

KNOWLEDGE

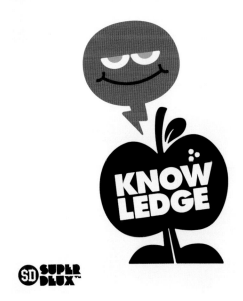

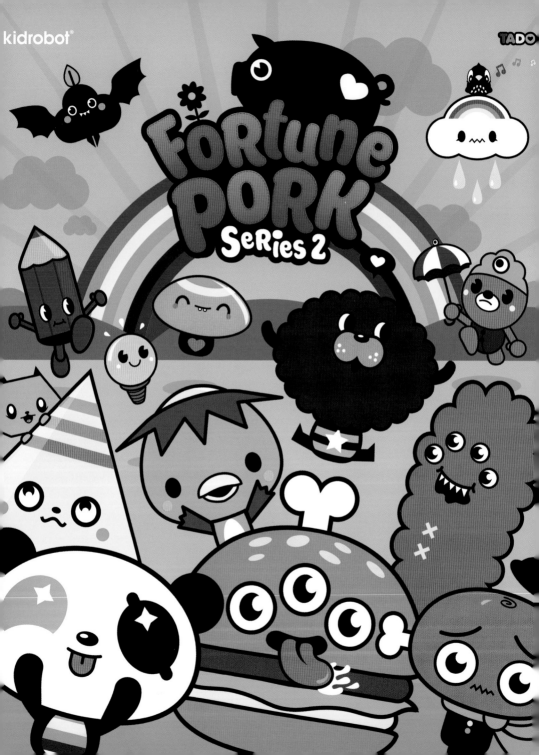

p160
FORTUNE PORK SERIES 2
Mini plush toys produced by Kidrobot 2009
www.kidrobot.com

p161
SUGAR BOMB
Wall vinyl mural produced by Domestic
www.domestic.fr

TADO is comprised of Mike Doney and Katie Tang, a couple living and working in Sheffield, UK. Their small studio is the source of adorable characters created to the delight of their clients the world over. TADO loves to embark upon all kinds of projects, everything from publicity, illustrations, fashion, toys, and art exhibitions. TADO's strengths are their little kawaii animals, their great sense of humor, and excellent use of space in their designs. One of the most fascinating things about TADO is that every new project surpasses the popularity of the previous one. This studio's desire to experiment and create is inexhaustible. Not for nothing is this one of the most famous studios in Western kawaii art.

TADO
Sheffield, United Kingdom
www.tado.co.uk
mikeandkatie@tado.co.uk

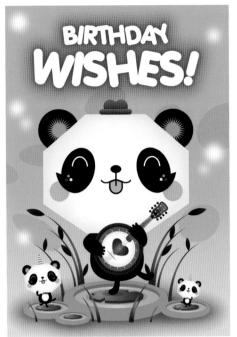

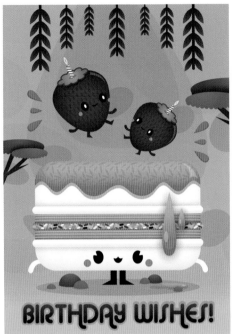

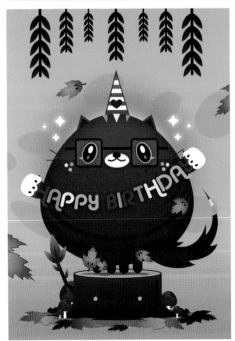

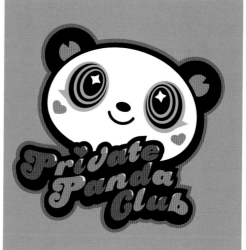

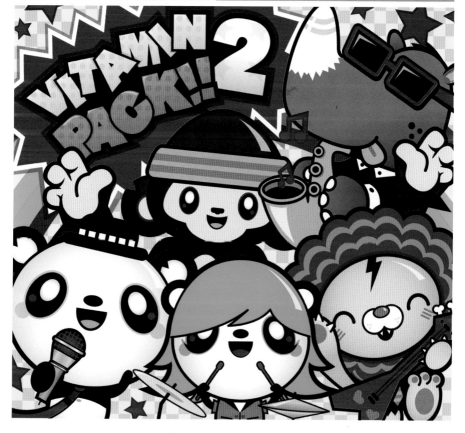

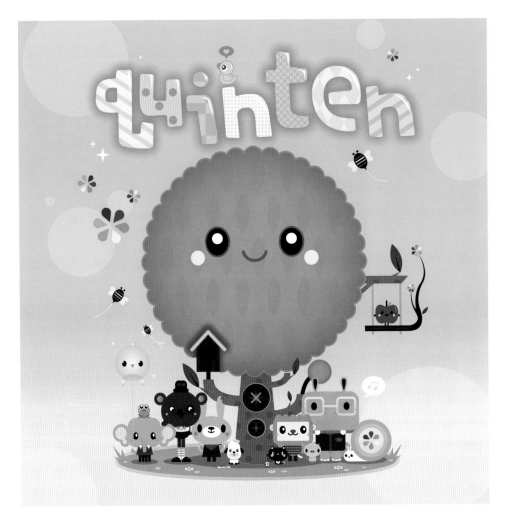

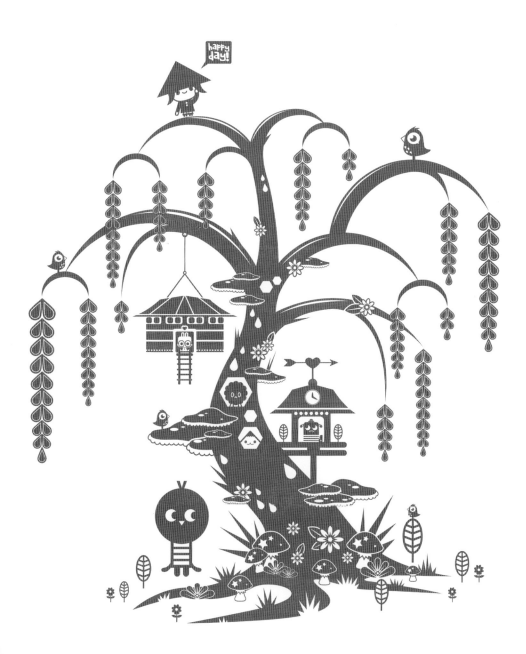

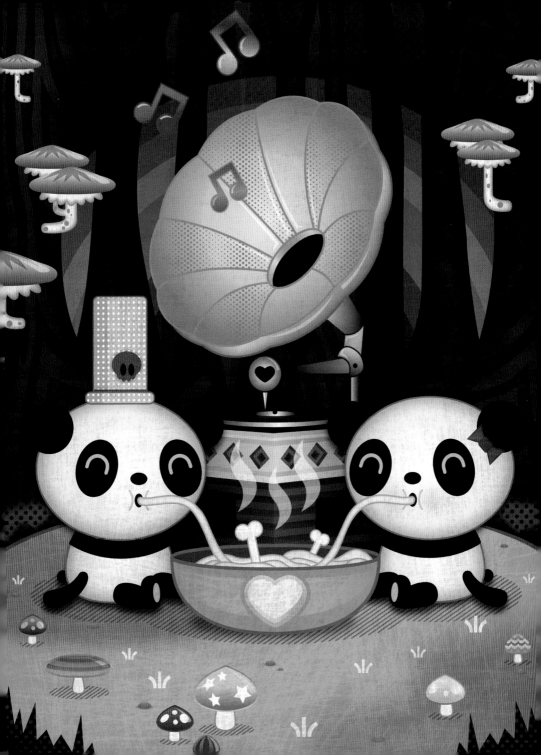

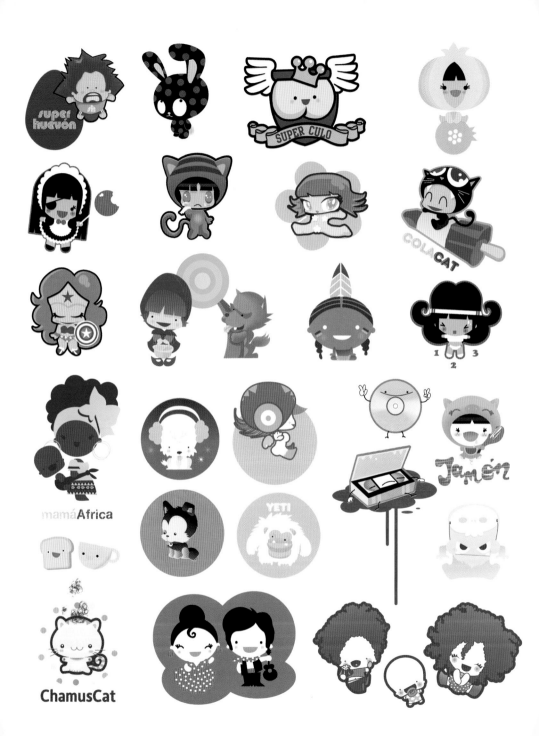

super
huevon

SUPER CULO

COLA CAT

1 3
2

mamáAfrica

Jamón

YETI

ChamusCat

Terelo, who is also known as Gazpachan, is one the greatest admirers of kawaii culture in Spain. This was evident by the Puni-Puni exhibition, a show created by a group of Spanish and Japanese artists as a tribute to this delightful art. Terelo's style could be perfectly described as kawaii-folkloric. She herself says that what she likes more is to place herself between stoves and mix the traditional flavors of gazpacho from her birthplace Andalucia, with ingredients from the Japanese kawaii culture. The result amounts to original and exquisite dishes of gastronomic delights packed with characters served in the form of illustrations for magazines, T-shirts, vinyl, amigurumi, etc...

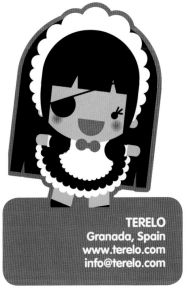

TERELO
Granada, Spain
www.terelo.com
info@terelo.com

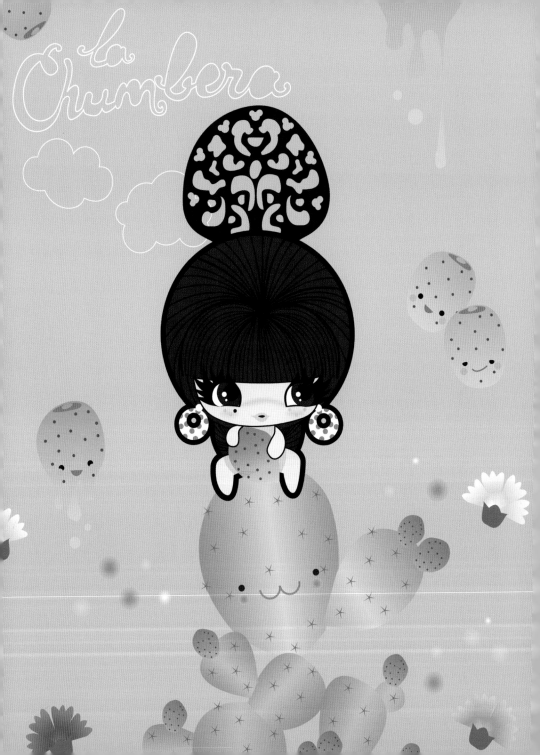

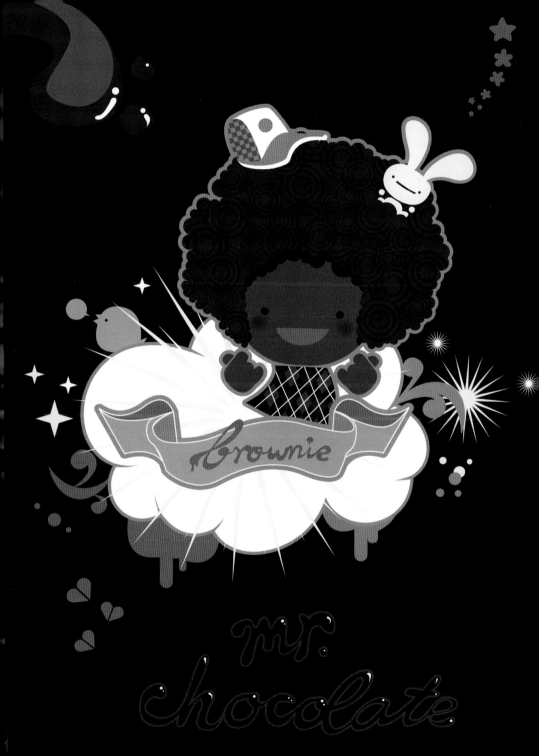

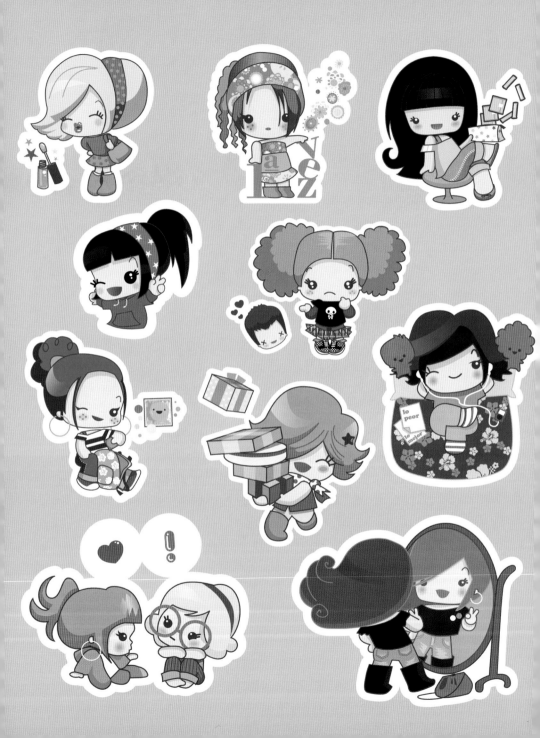

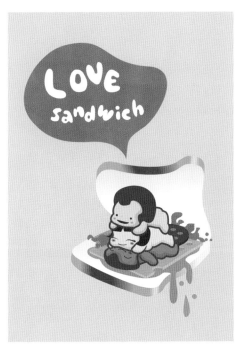

p172
SUPERPOP
Illustration for the magazine *Superpop*

p173
SANDWICH
Illustration for the sex section in the *EP3*
supplement in the *El País* newspaper

SCHOOL
Glacée for the exhibition Mister Pink
Galería Valencia, 2007

PIONONO KING
Glacèe for the exhibition Puni Puni, 2008

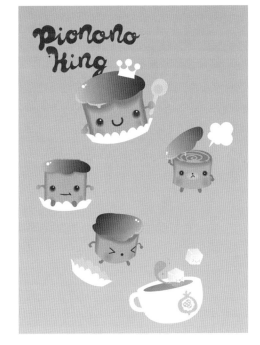

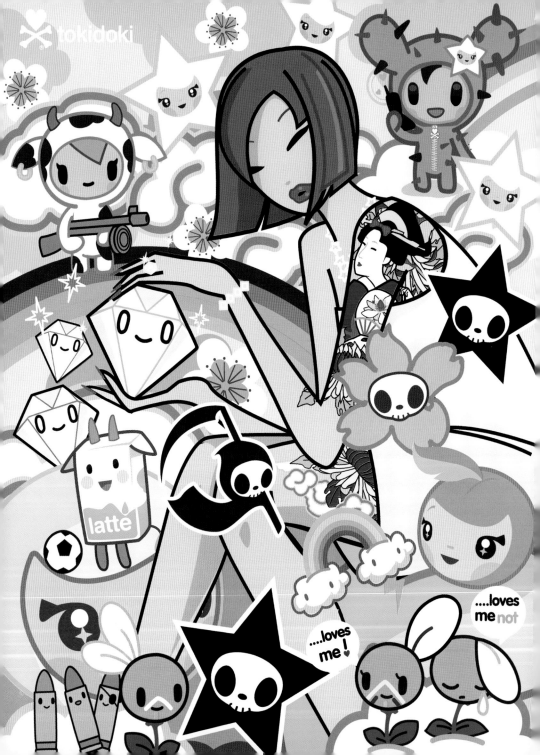

From Rome to infinity and beyond. Simone Legno is the tireless artist responsible for the world of Tokidoki. Simone had long endeavored to bring a little of Japan to the rest of the world. Her dream was finally fulfilled when she received an invitation to create his own brand. Simone packed his characters in a suitcase and left for Los Angeles, California. Little can be said of this artist that experts don't already know. Tokidoki is undoubtedly one of the most industrious artists on the kawaii scene. His cache amounts to some tremendously modern graphics, a great deal of sparkle, and a genuine devotion for his work, to which he devotes nearly all of his time.

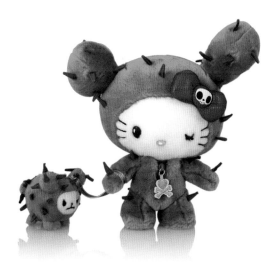

TOKIDOKI
Los Angeles, USA
www.tokidoki.it

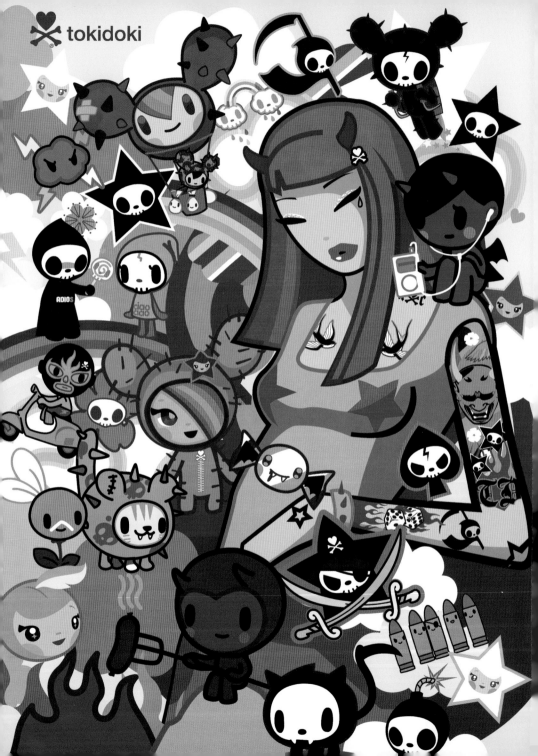

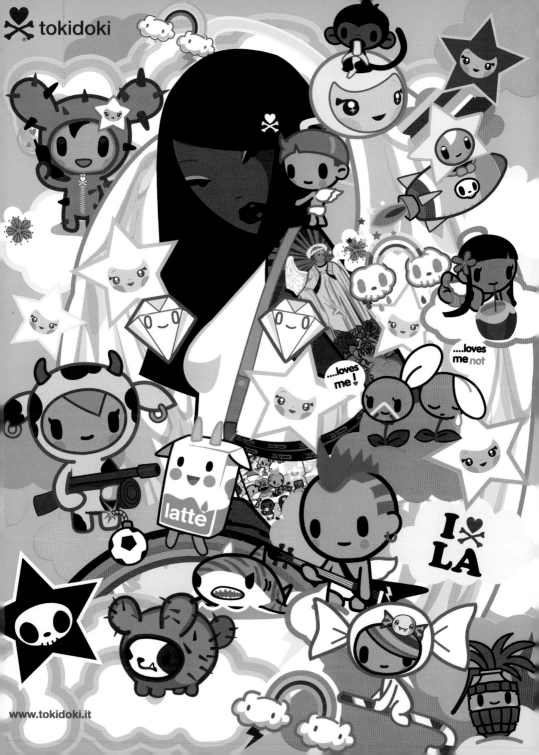

p178–179
TOKIDOKI FOR HELLO KITTY PLUSH
© 1976, 2009 SANRIO CO., LTD
© TOKIDOKI, LLC.
Designed by Simone Legno

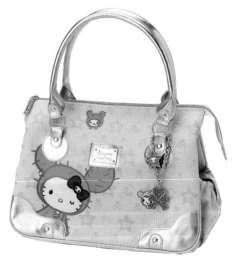

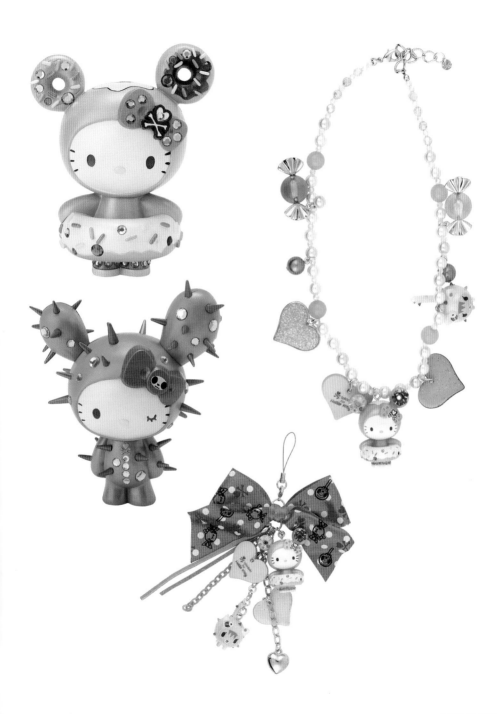

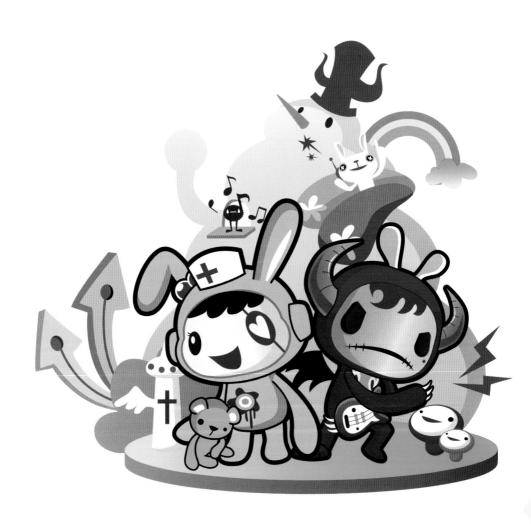

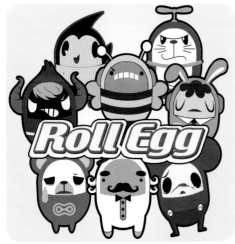

Toto Wang presents us with a very personal and sur-real interpretation of kawaii art equally in the design of her characters as in their backgrounds and settings. The artist's personal life may have directly impacted the dark nature of her artwork. Toto lost her sight for a short period of time, during which she took refuge in music and her inner world. She heads the Taipei-based No.22. Creative Studio. This studio has also been responsible for all types of merchandising and some very unusual vinyl figures, true to the vision unique to Toto.

TOTO WANG
Taipei, Taiwan
www.ilove22.com
22@ilove22.com

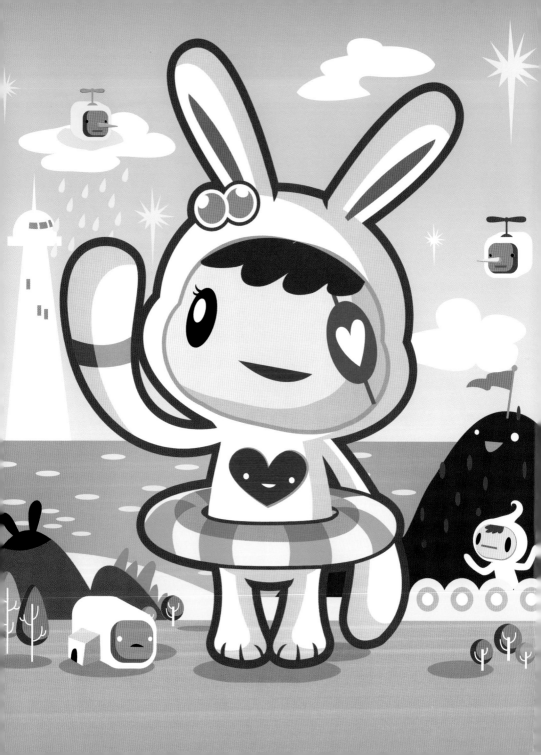

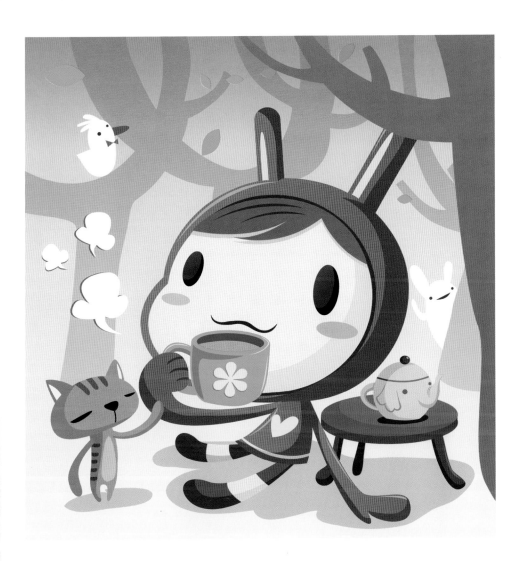

p182
HAPPY SUMMER

p183
TEA FOR LOVE

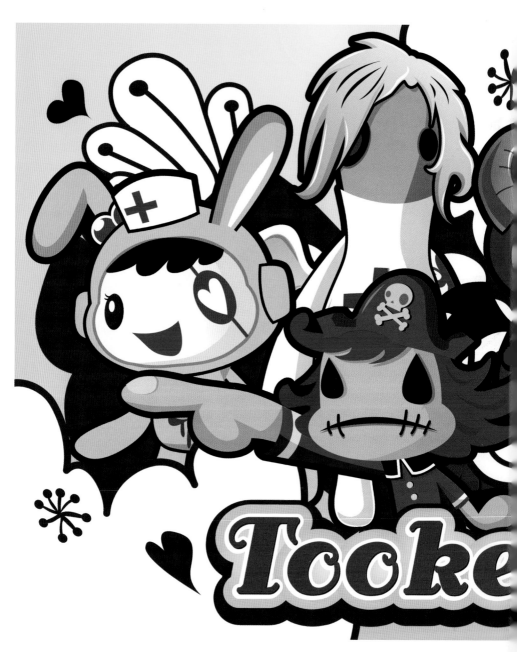

p184–185
TOOKER

p185
LUCKY BUNNY

OR DIE.

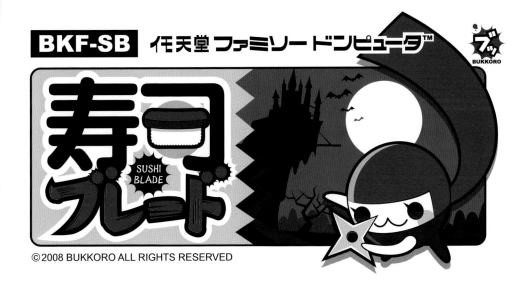

Yukiko Yokoo is a Japanese artist who specializes in graphics for video games. I became enchanted with her art on one of my trips to Japan when I discovered Taiko Drum Master, the most kawaii-influenced video game I have ever seen in my life, designed by Yukiko. Nobody humanizes objects like Yukiko. She says that she likes to combine the traditional Japanese concept of kawaii with pop art. Another of her favorite combinations is that of kawaii and the grotesque, a fusion she refers to as "gro-cute."

YUKIKO YOKOO
Tokyo, Japan
www.bukkoro.com
nya-kuso@bukkoro.com

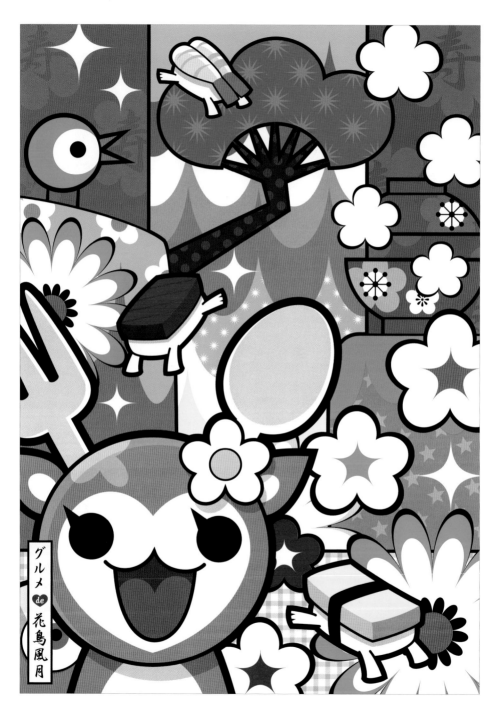

グルメ de 花鳥風月

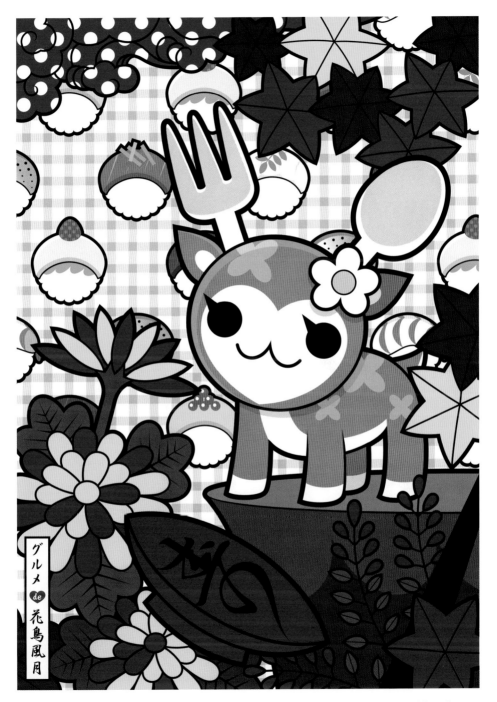

グルメ de 花鳥風月

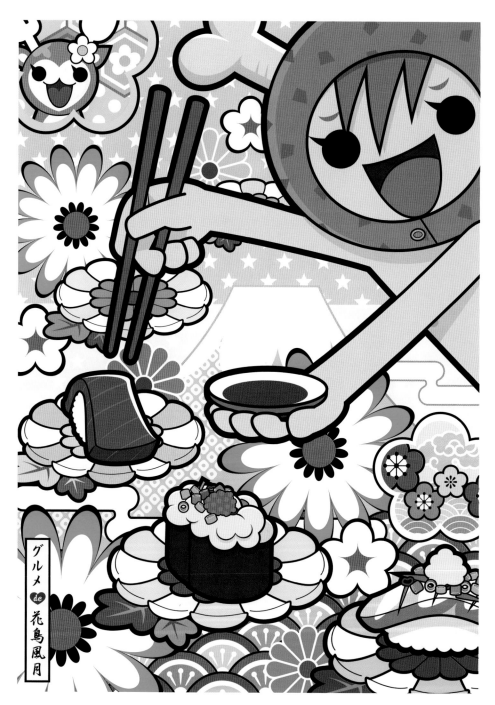

グルメ de 花鳥風月

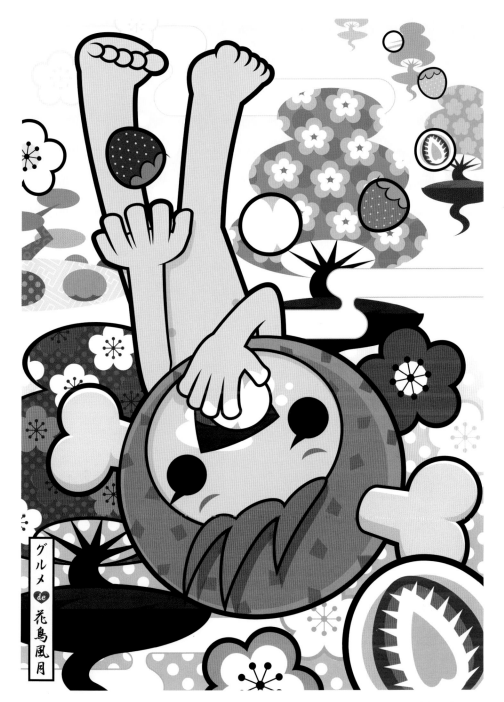

グルメ de 花鳥風月

© CHARUCA

My mother (a bright woman) says good people show their gratitude, so my thanks go out to the following:

To Rubén García and MONSA for their trust in this project from the start.

To Yukari Kawabata for her tremendous help with the Japanese translations. Thank you! Arigatou!

To Pablo Moreno for his great advice and wholehearted support.

To Terelo for helping me to revise the texts and for being so enthusiastic.

To all the artists who have contributed to this book. You have improved my life.

To my family and friends.